painting
Crystal and Flowers
IN WATERCOLOR

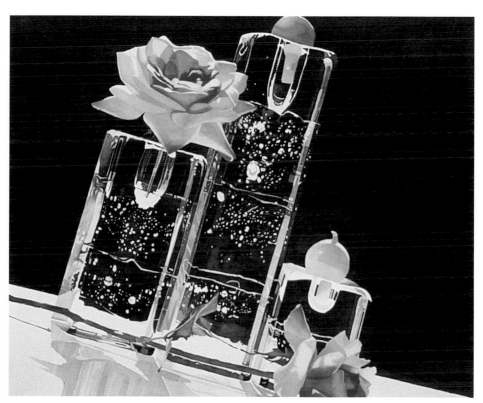

Homage to Frank and Falling Water
45" x 50" (114cm x 127cm)
Collection of Robert Ura and Trisch Brega

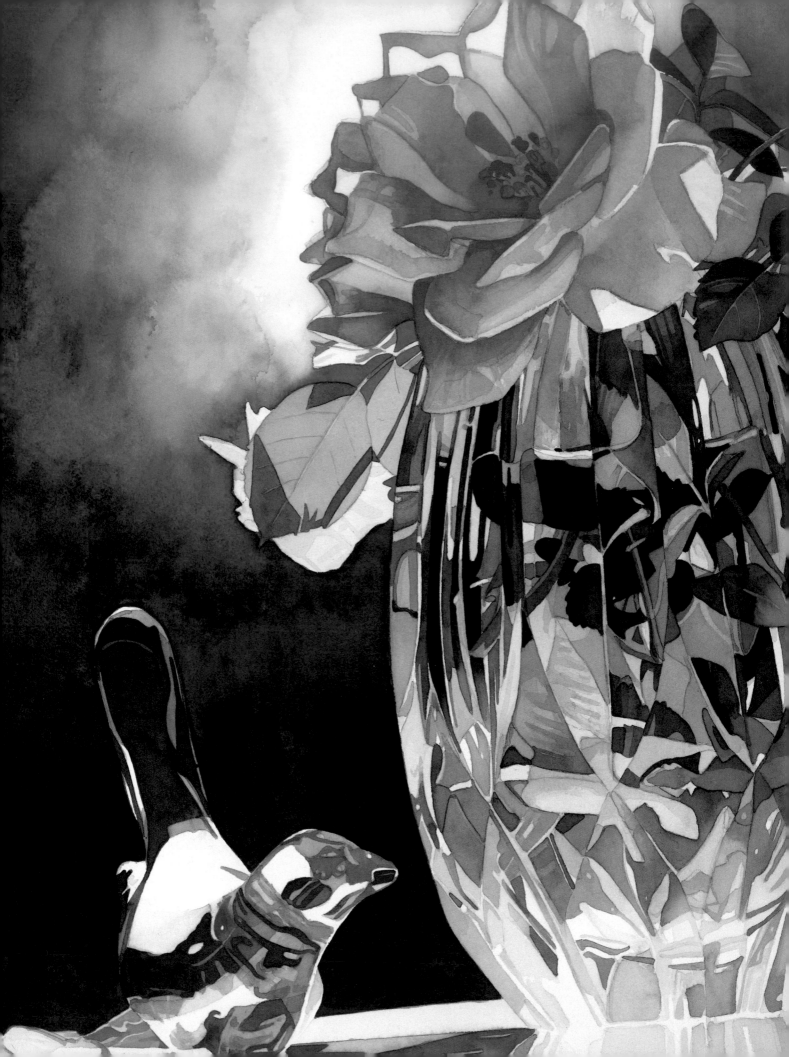

painting
Crystal and Flowers
IN WATERCOLOR

Susanna Spann

NORTH LIGHT BOOKS
CINCINNATI, OHIO
www.nlbooks.com

Acknowledgments

Thanks to my mom, Alice, who raised five kids alone and never wavered in her belief that each child could be whatever he or she dreamed. Her quiet strength and steel reserves flowed through the blood of the noisy and loving Spann clan.

To my sisters, Christina Spann Hammond and Toni Kay Spann Johnson, both artists in their own right. The two of you let me drag y'all to galleries for years without a peep of protest!

To my trusted friends Janette Dunnigan, whose crystal bowl I borrowed for so long, and Linda Molto, an artist who understood the dilemma of doing art for art's sake and art to pay the bills. To the warm and loving old friends who believed in me when I didn't: Jeanie Eller, Ed Shipp, Merrinell Phillips, Pat Locklear Evertsen, Suzy Mack Evans, Don Beamon, Zollie Cowart, Martie Cowie, Bob Denton and Gregg Minkoff. And to the new friends who encourage and applaud skills that took a lifetime to hone: Janice Campbell and John Timson.

To the wonderful editors of North Light Books—Rachel Rubin Wolf, Kathy Kipp and Jennifer Lepore Kardux— for previously publishing some of my work and for allowing me the pleasure of writing my very own book.

And to Patrick Seslar who has written several books for North Light. His quiet encouragement through countless phone calls and E-mails helped me visualize my own way and kept me on my own path.

A very special acknowledgment and thank-you to all of the many patrons who have responded to and purchased my work over the years. It was your financial and emotional support that allowed me to be an artist and to explore, visually, a whole wonderful world of ideas. I still find it magic!

Painting Crystal and Flowers in Watercolor. Copyright 2001 by Susanna Spann. Manufactured in China. All rights reserved. No part of this book may be reproduced in any form or by electronic or mechanical means including information storage and retrieval systems without permission in writing form the publisher, except by a reviewer, who may quote brief passages in a review. Published by North Light Books, an imprint of F&W Publications, Inc., 1507 Dana Avenue, Cincinnati, Ohio, 45207. First Edition.

05 04 03 02 01 5 4 3 2 1

Library of Congress Cataloging in Publication Data

Spann, Susanna
 Painting crystal flowers in watercolor/by Susanna Spann..
 p. cm.
 Includes index.
 ISBN 1-58180-031-2 (hc.: alk paper)
 1. Flowers in art. 2. Glassware in art. 3. Watercolor painting—Techniques. I. Title.

ND2300 .S66 2001
751.42'2434—dc21 00-066857

Edited by Jennifer Lepore Kardux
Designed by Wendy Dunning
Interior production by Lisa Holstein
Production coordinated by Kristen Heller
Artwork on pages 2–3: *Splendor in the Glass*, 40" × 45" (102cm × 114cm), Collection of Darlene and Charles Wolohan

METRIC CONVERSION CHART

to convert	to	multiply by
Inches	Centimeters	2.54
Centimeters	Inches	0.4
Feet	Centimeters	30.5
Centimeters	Feet	0.03
Yards	Meters	0.9
Meters	Yards	1.1
Sq. Inches	Sq. Centimeters	6.45
Sq. Centimeters	Sq. Inches	0.16
Sq. Feet	Sq. Meters	0.09
Sq. Meters	Sq. Feet	10.8
Sq. Yards	Sq. Meters	0.8
Sq. Meters	Sq. Yards	1.2
Pounds	Kilograms	0.45
Kilograms	Pounds	2.2
Ounces	Grams	28.4
Grams	Ounces	0.04

Dedication

To the one person in my life who saw and felt each baby step forward and every marathon backward, my beautiful daughter, Diannarose.

Susanna Spann earned a B.F.A. and an M.A. from Arizona State University, and spent the following two years working and painting in Europe, where she held two solo exhibitions. Upon returning to the United States she attended three years at The Art Center College of Design in Los Angeles in the field of illustration.

In 1977 Susanna moved to Bradenton, Florida, and opened her own studio. She presently exhibits in twenty to twenty-five outdoor art festivals a year and teaches water-color workshops across the country. For many years Susanna was a part-time instructor at the Ringling School of Art and Design in Sarasota, Florida.

Susanna Spann has received more than five hundred awards in local, state and national competitions. She has earned signature memberships in the American Watercolor Society, National Watercolor Society and Florida Watercolor Society. Her work is hung in many corporate collections, including Disney World, Nations Bank, Tampa Electric Company, City of Miami and United First Federal. She has exhibited in the prestigious watercolor exhibitions of the American Watercolor Society in New York, Watercolor U.S.A. in Missouri and the National Watercolor Society in California.

Her work has appeared in *Splash 1*, *Splash 2*, *Enliven Your Paintings With Light*, *Painting With the White of Your Paper*, *The Best of Flower Painting*, *Best of Flower Painting 2*, *The One-Hour Watercolorist* and *The Artist's Illustrated Encyclopedia*, all published by North Light Books. Susanna's work has also appeared in numerous magazines, including *The Artist's Magazine*.

Presently Susanna has forty-five floral images in offset reproductions that are distributed nationwide through art fairs and galleries.

Table of Contents

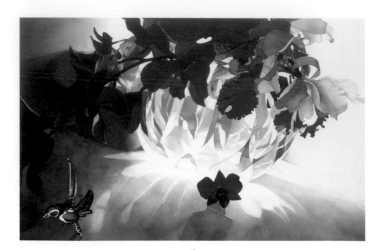

Painting From Photographs
12

Photographic Materials ❧ Setting Up Flowers for Your Photo Shoot ❧ Setting Up Crystal for Your Photo Shoot ❧ Other Tips for Photo Shoots ❧ Shooting Outside Vs. Shooting Inside ❧ Picking the Best Photos ❧ Cropping Your Photos

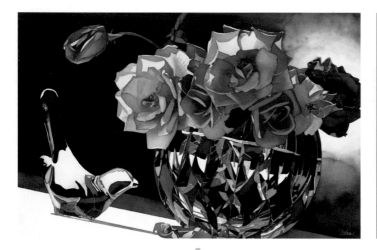

Charisma of Color
56

DEMONSTRATION | *Experiment With Color Wheels* ❧ Color Families and Schemes ❧ Color Mixing to Give Dimension ❧ Using Base Colors ❧ DEMONSTRATION | *The Color of Clear Crystal* ❧ DEMONSTRATION | *Create Color From in Front of Crystal* ❧ DEMONSTRATION | *Create Color From Inside Crystal* ❧ DEMONSTRATION | *Create Color From Behind Crystal*

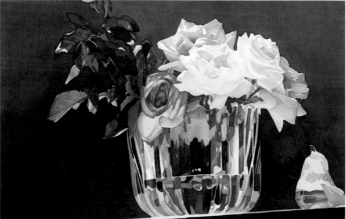

Addition of Elements
82

DEMONSTRATION | *Smoky Backgrounds* ❧ Rainbow Backgrounds ❧ Graded Backgrounds ❧ Whispery Backgrounds ❧ Solid Backgrounds ❧ Using Formed Shadows ❧ Using Cast Shadows ❧ Ambient Color ❧ Elements of Elegance

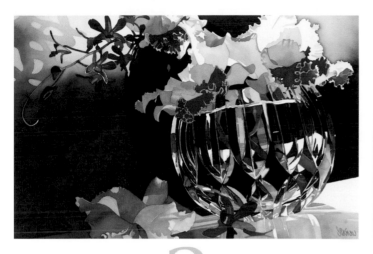

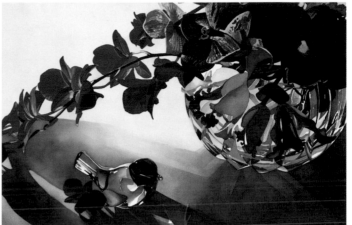

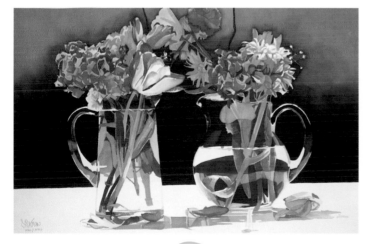

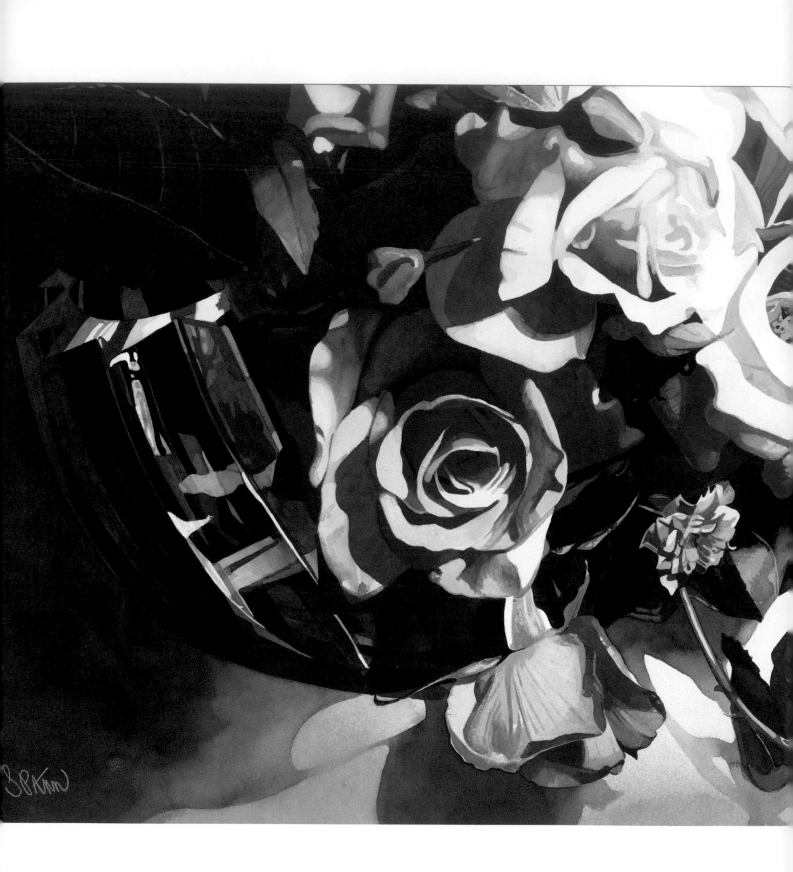

Introduction

The visual beauty of sparkling crystal and delicate flowers still brings tears to my eyes after years of painting this subject. There is something ethereal and elegant in the image of a crystal vase dazzling in the morning sunlight surrounding a bouquet of sweet-smelling roses. The tranquil pleasure of feeling satisfaction with the universe flows through all of the senses.

I stumbled into this magical marriage between two opposite textures with a commission piece and the borrowing of a bowl from a good friend. Over the years, paintings with glass objects and flowers have been symbolic to me, depicting the various chapters of my life. These textures allow me to create something absolutely gorgeous while keeping a personal record of life's joys and sorrows, successes and defeats.

To look at this phenomenal and enchanting piece of beauty and wish to paint it can be quite intimidating. Begin by understanding what crystal is. Close your eyes and let your imagination feel the texture of the glass. It is a hard-surfaced object. Touch the curvature of its individual shapes; visualize the solidity and weight. Open your eyes and study how the light passes through the facets. Gaze at the glow of color a flower may add, and behold the life that flows through this combination. It is absolutely breathtaking!

It is my wish to help the artist go from looking at something beautiful to creating it on paper. This will be accomplished by reopening your eyes and showing you how to "see" with a new kind of awareness. This is the first step to creating anything.

With this book I hope to share a little of my spirit and a lot of my skills to enhance your own journey through the painting of crystal and flowers. So come along and hang on for this amazing ride!

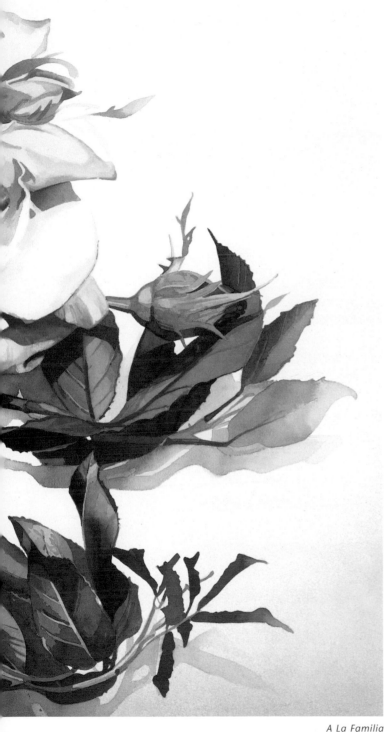

A La Familia
25" x 45" (64cm x 114cm)
Collection of Marni and George Johnson III

Assembling Materials

Paper

Paper choices may dictate your painting style. There are hundreds of surfaces in watercolor paper but basically two main textures. Hot-press papers have a totally flat surface much like an ice-skating rink. Cold-press papers have a textured surface much like mountains and valleys. I work with 300-lb. (638gsm) rough paper, which has very high mountains and very deep valleys. This allows my glazes to sit in the valleys and slowly creep up the mountains, giving the work a luminosity that I don't get with other paper surfaces.

Paint

I have found over the years that I prefer Winsor & Newton watercolors. They are predictable and consistent, and I can get them anywhere in the world. I also like the Daniel Smith Quinacridone series and have begun using them more frequently the last couple of years.

Brushes

The Winsor & Newton Series 7 brushes numbers 000 through 6 rounds are fantastic. I was trained as an illustrator and love my Series 7. I have tried others over the years and always go home to my magnificent brushes. These are small brushes, but I like the weight of them in my hand and the amount of water they hold. The points stay good a long time and turnover in brushes is less common. When working, I place them in a small, clear plastic glass so I can easily see which one I want.

Palette

A white butcher tray is my favorite palette as it allows me to clearly see the correct colors of the paint mixtures. I use a John Pike palette for traveling, as it is designed for portability. In my studio I may have three palettes mixed at the same time with various temperatures of color. It is my way of working on several paintings at a time.

Other Supplies

Bounty paper towels are used to pick up any paint that has dropped from my brush onto surfaces that I don't want painted upon (they really are great absorbers). I also use the paper towels to soften some backgrounds.

A small plastic glass is used to hold the water for the painting process. If it's the right size, it allows you to never have to move your fingers from the center of your brush. I call this "economy of motion."

A small plastic food container makes a great carrying case when I want to paint away from the studio. I use it to hold my paints, brushes and reference photos. It fits easily into a portable shoulder bag.

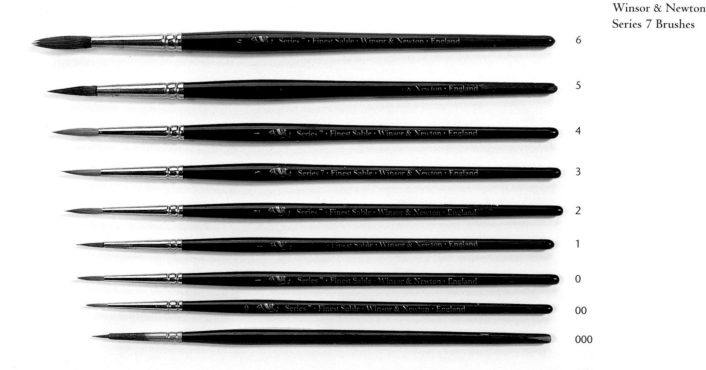

Winsor & Newton
Series 7 Brushes

6

5

4

3

2

1

0

00

000

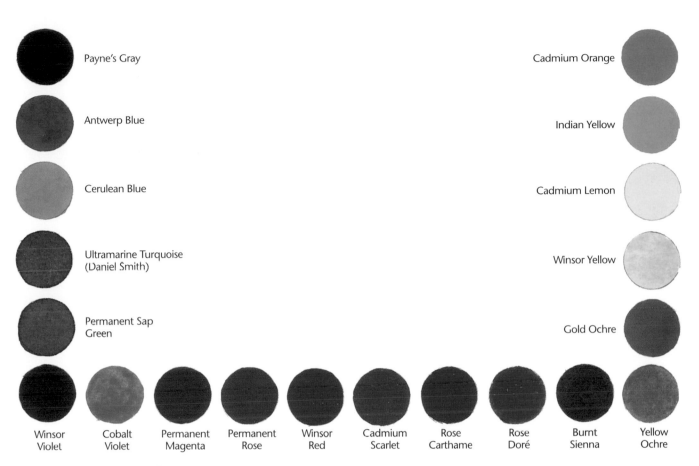

Payne's Gray

Antwerp Blue

Cerulean Blue

Ultramarine Turquoise
(Daniel Smith)

Permanent Sap
Green

Cadmium Orange

Indian Yellow

Cadmium Lemon

Winsor Yellow

Gold Ochre

| Winsor Violet | Cobalt Violet | Permanent Magenta | Permanent Rose | Winsor Red | Cadmium Scarlet | Rose Carthame | Rose Doré | Burnt Sienna | Yellow Ochre |

My Basic Palette of Colors | I may add colors or delete them from this palette as I design for a particular painting.

Susanna at work making value scales.

Painting From Photographs

Photographs are the memory for a painting. Being able to shoot and design from photos is an asset to the artist. My particular style of painting is called photo-realism, and the majority of the paintings I do are from photographs. Using photos has worked for many artists over the years due to a photograph's portability and accessibility. You can take your photos and watercolors almost anywhere: a cluttered studio, a roadside picnic table, an out-of-state workshop or an air-conditioned motel room.

The most important thing to remember when working from photo reference is to shoot your own film! In the Renaissance, students painted in museums and copied from the world's finest masters. This is still a good way to learn, but do not sell or enter competitions with work from other people's photos or paintings. It's illegal. This chapter will show you how to take shots that will work for you, providing you with great photo references of your own crystal and flower still lifes.

Sundances and Second Chances
40" x 60" (102cm x 152cm)
Collection of Beverly and Alan Fraser

Photographic Materials

Camera Equipment

What to buy? Get a camera with a zoom lens that has a wide range of millimeter choices. Also, get the best that you can afford at the time. It is never wasted money! But don't confuse "best" with "complicated." You don't need to get the most complicated, as that will only frustrate you. My favorite camera for years was a Vivitar with a 28–135mm lens. When that one broke several years back and I found that the lens was no longer manufactured, I purchased a Minolta X-700 with a 35–135mm lens. I'm not a professional with cameras or lighting, but I can make it work for the reference I need.

Film

For warm tones in paintings, I use Kodak 100 or 200 ASA print film. For cool tones, Fuji 100 or 200 ASA works best.

Lights

To photograph crystal and flowers, set up a composition on your studio table. Arrange your objects on a piece of foamcore or table-cloth, with lights on either side. For the light on the left, use a gooseneck lamp with a pro-fessional General Electric photoflood EBW, no. B2 115–120, which can be purchased at any photo shop. In the light on the right, place a regular 75-watt bulb on a stationary clamp. Attach this light to a shelf on your studio wall or the back of a chair.

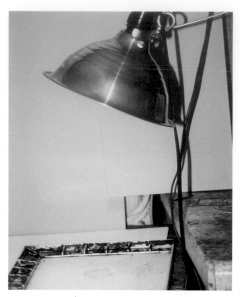

Clamp Light | By clamping a light to the right of my palette, I can see the precise colors of my glaze mixtures.

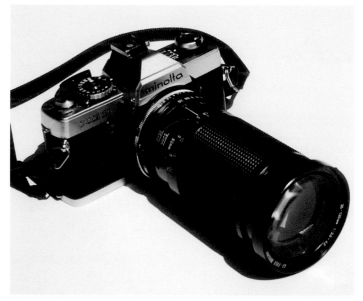

Camera | The 35–135mm lens lets you compose through the camera.

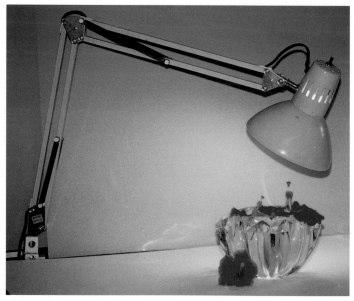

Gooseneck Lamp | Leave a regular 75-watt bulb in the gooseneck lamp until you are ready to shoot the film. At this time place the photoflood in the socket. Turn it off quickly after shooting the film, as the bulb gets very hot and will fry anything near it, including your hand.

The gooseneck light with 75-watt bulb is the perfect light to paint from. It can be moved around so you can place it as close as possible to the area you are painting on. I place mine on the left so the shadow of my right painting hand is not thrown on my view of the paper.

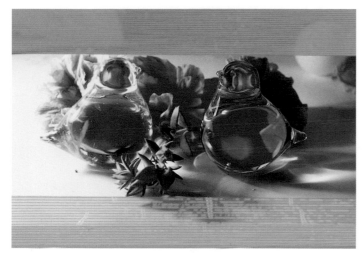

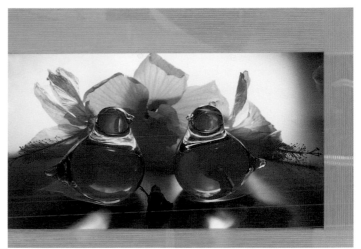

Poor Photo | The color of the crystal birds is good and clear, but the values are not varied enough. Also, the flowers in the background have too many similar shapes. The center bud is too busy and complicated.

Good Photo | The crystal birds here have a rich, caramel color with a variety of values throughout. The flowers have more variety in shape and color as well. The center flower isn't overpowering and is a good addition to the design.

Dixie Dancers
40" x 60" (102cm x 152cm)
Collection of Dr. Tom and Maryann Goodnight

Setting Up Flowers for Your Photo Shoot

When setting up a photo shoot, choose your floral arrangement with a variety in size, texture, color and shape. Review your compositions through your viewfinder before shooting the film. This will save you from poor photos and frustration!

Awkward Edges and Similarities | Blossoms should not face the same direction. Overlap edges for interest. Here, they just touch.

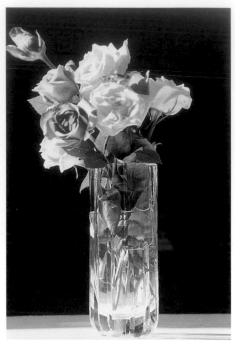

Crowded Arrangement | This vase has too many flowers, making foliage and blooms too busy. There are no quiet areas.

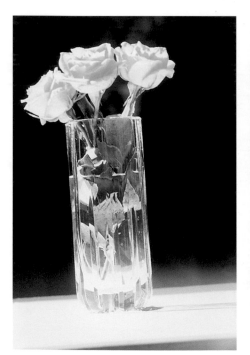

Repetitive Sizes | The size of these flowers is too similar, making them look like cookie-cutter images.

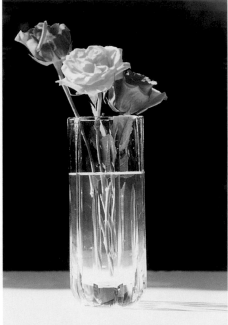

Sparse Arrangement | This arrangement needs more leaves and less "leggy" stems. The stems should not be positioned directly in the center of the vase at the bottom. Work to produce negative areas that are more varied.

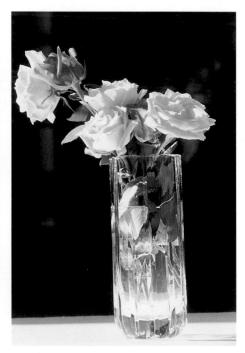

Good Composition

Setting Up Crystal for Your Photo Shoot

Sparkle is the spirit of the crystal. Your vase will have the maximum sparkle if it is lead crystal rather than glass or plastic. The fewer the number of facets, the easier it is to see and paint your crystal. Orrefors and Kosta Boda are fantastic manufacturers of lead crystal; their simple lines break up patterns and produce clean designs. Getting crystal to sparkle outside is easy with full sun. An overcast or cloudy day will just dull the crystal. Don't waste your time photographing outside unless it is a sunny day.

With an inside shot, move the gooseneck lamp in front of, in back of or above the crystal vase. You will be able to see the stunning sparkle that occurs when the light hits the crystal facets. This brilliant white will be the lightest value when you paint your piece.

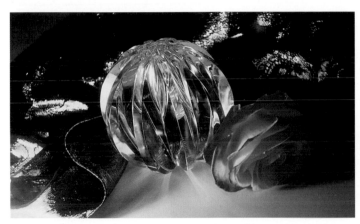

Too Busy | This vase has too many facets. They will be confusing in a painting.

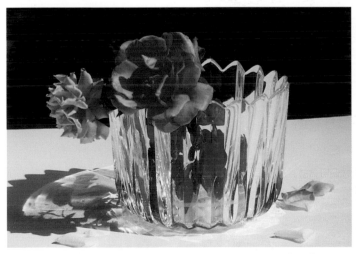

No Contrast | This setup lacks sparkle. The crystal does not "sing."

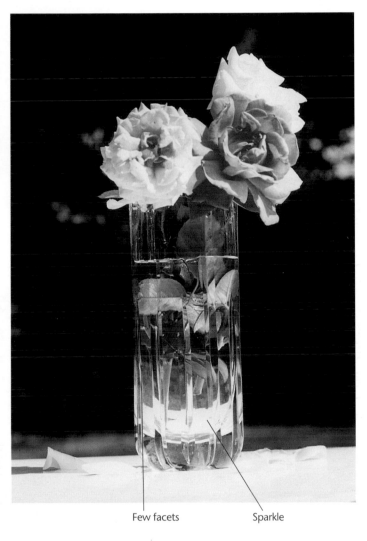

Few facets Sparkle

Good Composition | Select crystal that is simple in design. Set up your crystal in maximum light.

Other Tips for Photo Shoots

Value

Look at the flowers and their value relationships to one another. A petal may need to be backlit, or perhaps a leaf darkened for eye appeal. To get this effect, place your light behind or under the flower, creating a translucent shine. This adds more drama and punch.

Shadows

Long shadows create a magnificent, graceful sweep. Look for relationships between hard-edged crystal and soft-edged flowers.

Good Values | Shining a strong light on your subject can be tricky, as the flower will wilt if the light-bulb is too close or left on too long.

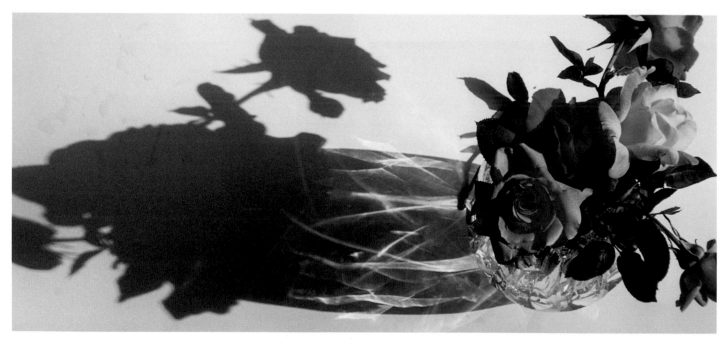

Interesting Shadows | Overlapping and interlocking the shadow and subject create a strong artistic partnership.

Negative Space

Negative space and positive space need to enhance one another, not battle for power.

Reflections and Refractions

Reflections and refractions give crystal its textural uniqueness. A *reflection* is light passing through the cut facets of the glass and descending onto a surface. Only lead crystal gives the incredible brilliance that takes your breath away, but other glass can be just as pretty when put in a painting.

Refractions are color and value changes within the glass object itself. This results from the bending of color and shape (stems, leaves, waterlines, etc.) along the lines of the facets of the cut glass.

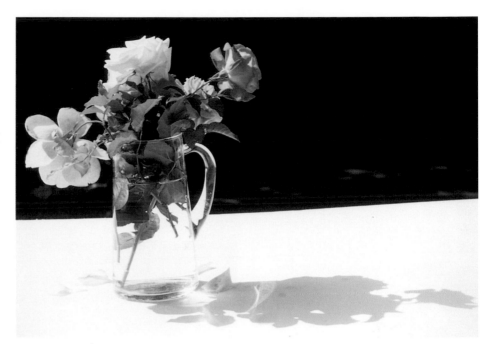

Negative Space | The strong negative of a dark background and the stark white table contrast with the gray shadow.

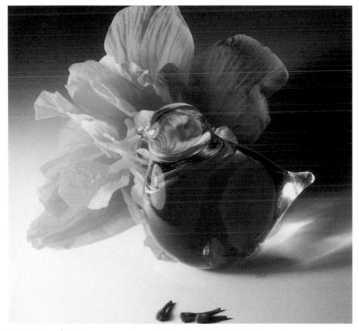

Reflection | Light passes through the glass bird and reflects shapes on the tabletop.

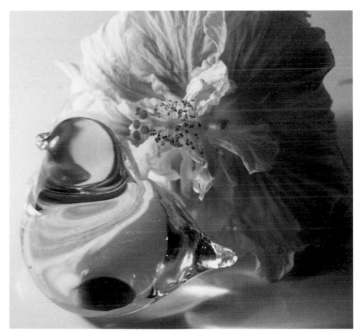

Refraction | The cream color of the hibiscus is refracted in the crystal bird. The round shape of the glass bird causes the flower shape and color to distort.

Shooting Outside Vs. Shooting Inside

There are two kinds of photographic shots that I utilize: studio and outside. Each produces a different feeling.

Studio Shoot

The studio shoot is quieter, more velvety, and has reflected shadows. After analyzing your composition through the camera's viewfinder, shoot some film and turn the photoflood off. Let it cool down. Then shoot from a different angle. Change the light around. Recompose the objects and reshoot. You may shoot several rolls of film to get just a few "paintable" photos. This is normal. Take film to a one-hour printer. Reshoot photographs of compositions that you liked but that didn't print well. When reshooting, use your new knowledge of what went wrong.

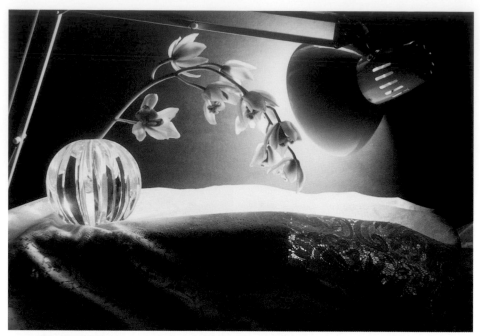

Your studio lamp can help you achieve a softening of your subject.

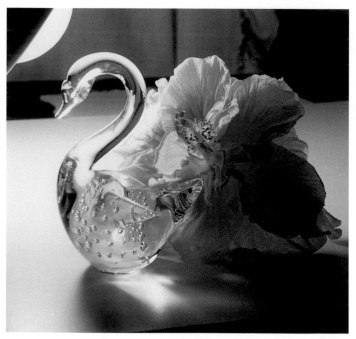

Try positioning your light so it shines through the crystal, giving your setup sparkle.

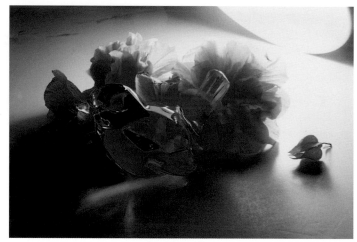

Place your light behind your subject for a dramatic backlit effect.

Outside Shoot

The outside shoot is starker and more dramatic. Since I live in the state of Florida, there is a powerful light facing southwest between two and four o'clock, emoting dark background values. I place a table for the props about 15' (5m) from the front porch.

Try setting up your composition in this type of lighting, placing it on foamcore. The blazing sun causes anything it shines upon to dazzle. This allows strong sunlight to pass at an angle through the crystal and encourages the shapes of dancing reflections.

If you prefer cooler hues, find a cooler place in your yard.

Outdoor
Shoot Setup

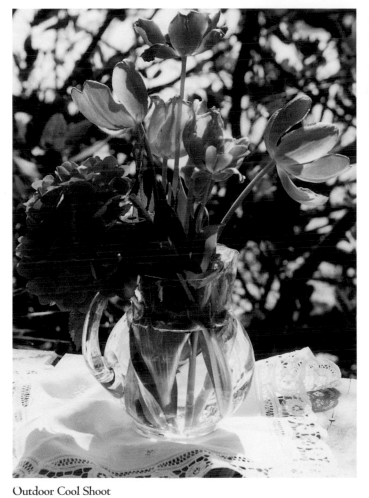

Outdoor Cool Shoot

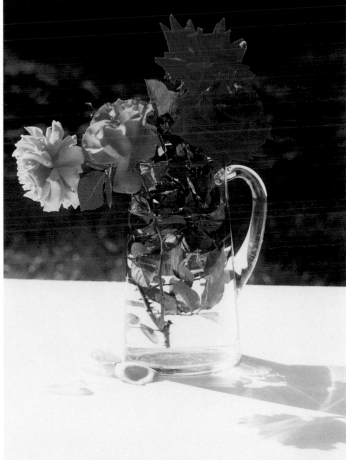

Outdoor Warm Shoot

Picking the Best Photos

I'm always excited after a photo shoot and immediately run down to get the film printed. Once your photographs are back, it's time to begin editing. View the photos with a few objectives or questions in mind that will help lead you to a good final painting.

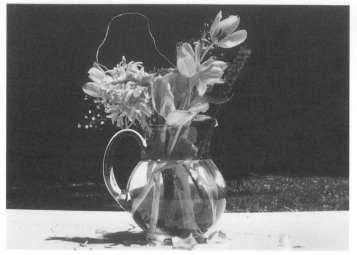

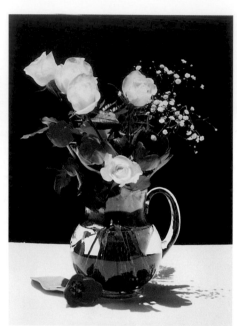

Is There a Full Value Range? | This weak setup has only mid-range values.

This strong setup has an entire range of values.

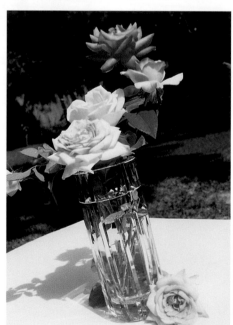

Are the Objects in Focus or Blurry? | The facets and flower here are fuzzy and hard to see.

Work to make the facets on your crystal clear and easy to understand.

"VALUE-ABLE" INFORMATION

See chapter two, pages 26–39, for detailed discussion and instruction on values and how they relate to your painting.

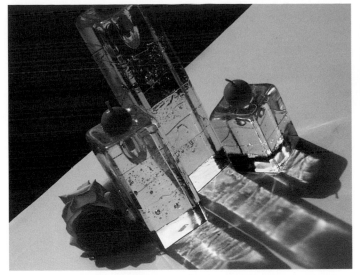

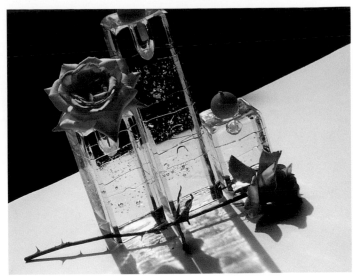

Is the Photo Over- or Underexposed? | This photo is overexposed and too dark, not allowing for good values or clarity of subject.

This photo looks just right. The number 1 values really sparkle.

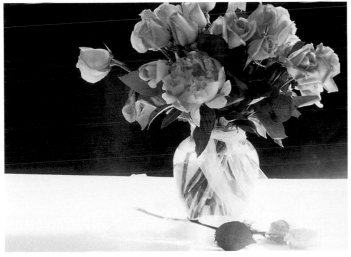

Is There Drama in Some Places, Softness in Others? | Drama is created here between the bold arrangement and the soft foreground and dark background.

Do the Color Values Move Well Through the Composition? | A full range of values are scattered throughout the shot, giving interest and playfulness for the eye.

MORE QUESTIONS

- *Is the composition through the camera lens what you planned?*

- *Are the colors accurate? This is important if you want them to be accurate, but colors can be changed if the values are right.*

- *Can parts of the photo be used for another painting? If the photo is just so-so but has parts that may be used in the future, keep it.*

Cropping Your Photos

Rarely is a photograph the exact size and composition that is needed for a painting. Cropping the photo allows you to get rid of any extraneous information and create a stronger design.

Use Other Photos as Mat Corners | Place your photo on a piece of foamcore. Lay other photos (the white backside up) or white pieces of paper on top of the photo to create mat corners that will help you find the best composition.

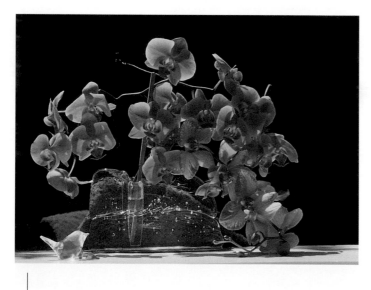

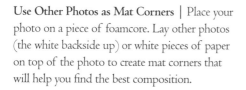

Paper added here.

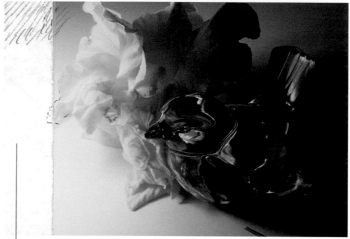

Paper added here.

Use Paper to Add to Your Photos | Add paper to the bottom of your photo to give you an idea of how it would look if it were deeper *(left)*. Add paper to the side of your photo to see what the composition would look like if it were wider *(above)*.

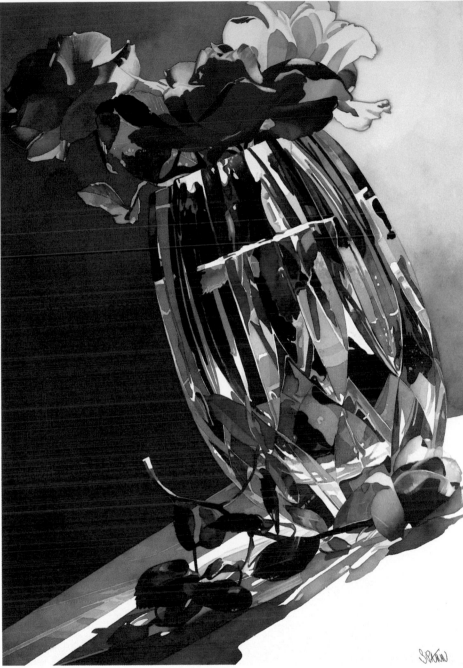

Tape out unneeded areas to crop into subject.

Use Tape to Crop | Once you've used one of the other cropping methods to find the composition you like, then put down masking or white tape to permanently mark your crops.

Desert Rose Dreams
60" x 40" (152cm x 102cm)
Collection of Sally and Elliot Perney

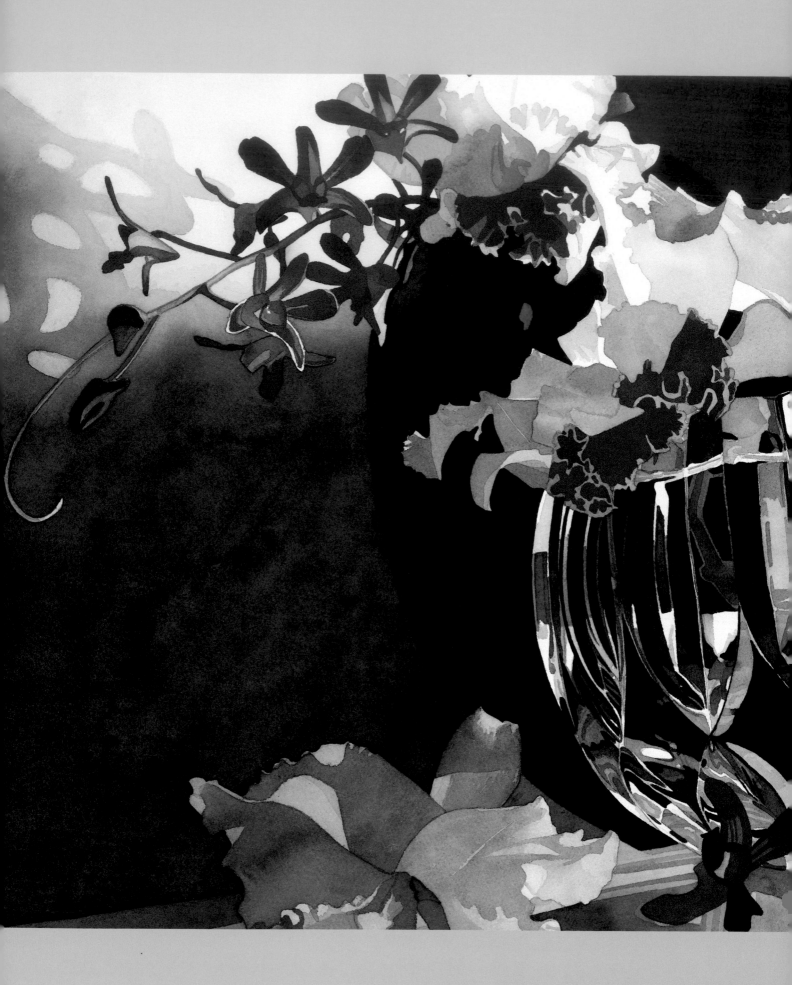

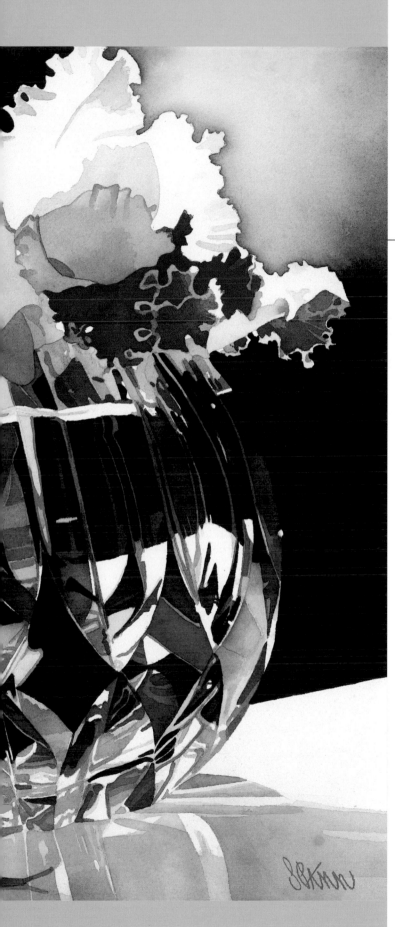

Validity of Value

The artist needs to understand and make good use of value in order to create crystal that appears three-dimensional. Value is how light or dark an object can become. It is the skeleton of a painting that gives structure to the sparkle of glass.

Just remember, it takes patience to paint crystal. To create three-dimensional crystal, it takes multiple glazes of paint to achieve the right values, letting each glaze dry before adding the next. This is a long process. Please don't give up! This method of achieving value will enhance your skills and make you a better painter. So, sit back, put on your favorite music and relax for a wonderful painting adventure.

Remembrances and Regrets
30" x 40" (76cm x 102cm)
Collection of Joanna and Paul Hall

MAKING A VALUE SCALE

Crystal and glass are full of different values. The white of the paper gives glass its radiance, making glass appear to be glass and not some other texture. In order to keep this sparkle, preplan your white areas. It is also necessary to put in darks to give the glass punch, drama or pizazz or just to make it look three-dimensional. Without the dazzling, preplanned whites and luscious rich darks, the glass object will be flat and will not appear to have the luster and brilliance you desire.

Making a value scale helps you to mix the correct value of paint as called for by your painting. You can place the finished scale on top of a color, object, photo, etc., squint your eyes to see which value you'll need and translate that value to your painting.

MATERIALS LIST

- *Surface* 10" × 1¼" (25cm × 4cm) strip of 300-lb. (638gsm) rough watercolor paper

- *Paints* Payne's Gray

- *Brushes* Round: no. 2

- *Other* Bounty paper towels
 Nickel
 Palette
 Paper hole punch
 Pencil

1 **Lay First Value** | Use a nickel and pencil to draw ten circles on the strip of watercolor paper. Do not let circles touch, as paint may bleed into neighboring circles. Label the circles from left to right, from "**1**" through "**10**". Leave the number **1** circle as the white of the paper.

2 **Lay Second Value** | Payne's Gray is a cool charcoal gray, good for mixing dark values. Mix a good-size puddle of paint, about 90 percent water and 10 percent pigment. Paint all the circles except the number **1** value with this light glaze. This is the number **2** value. It should look like weak tea. If it's too dark, dab with a paper towel. Let dry.

3 **Lay Third Value** | Mix the number **3** value by adding a tad more pigment to your previous color. Paint circles **3** through **10** with this color. Let dry.

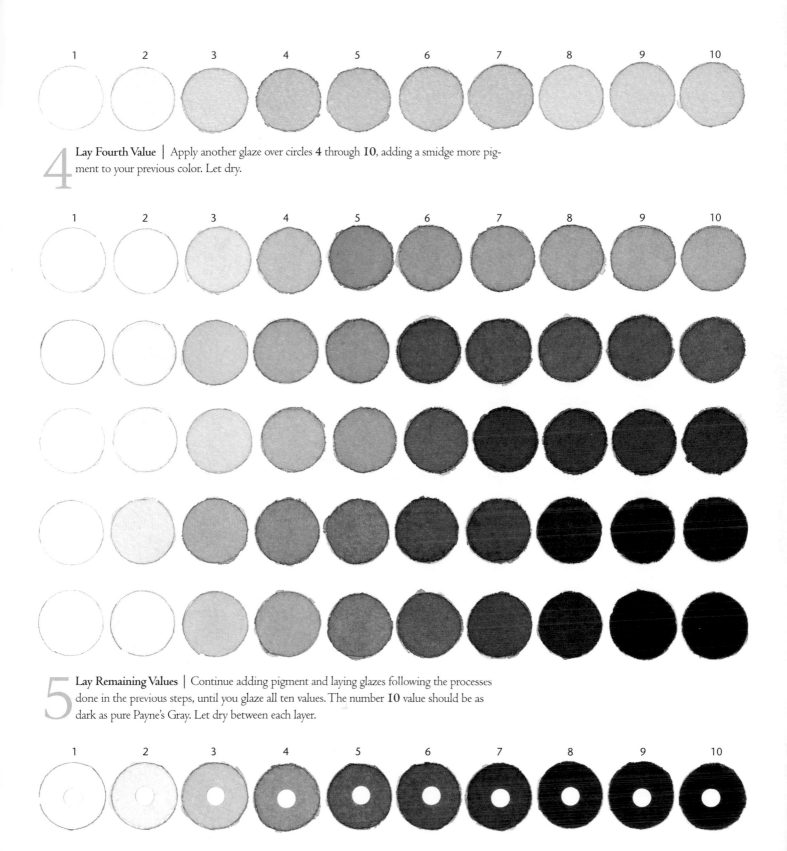

4 **Lay Fourth Value** | Apply another glaze over circles **4** through **10**, adding a smidge more pigment to your previous color. Let dry.

5 **Lay Remaining Values** | Continue adding pigment and laying glazes following the processes done in the previous steps, until you glaze all ten values. The number **10** value should be as dark as pure Payne's Gray. Let dry between each layer.

Punch Holes | When all the circles have thoroughly dried, punch a hole in the center of each. This will help you determine values of other colors by placing the value scale on top of another color.

High-Key Vs. Low-Key Paintings

High Key

Many artists prefer to paint with values 1 through 5 or so. This is called *high key*. High-key paintings have a light, pastel feeling. Watercolor is a perfect medium for this choice of values.

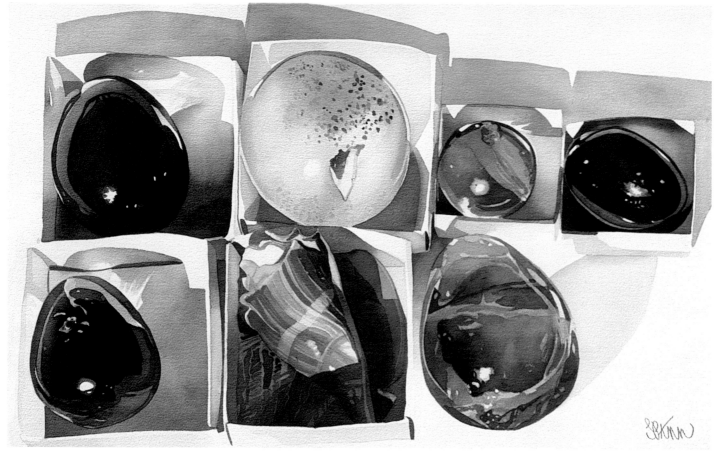

All of my work has the full value range. This one has the most light values, especially in the shadow and background areas.

Shell From Shell Island
Crystals in Containers Series
27" x 37" (69cm x 94cm)
Collection of Helen McFadden

Low Key

When choosing values **5** through **10** or so, a painting is said to be *low key*. These works have a heavy, somber feeling. Watercolor can be used to create low-key paintings, but oil is best for painting low key.

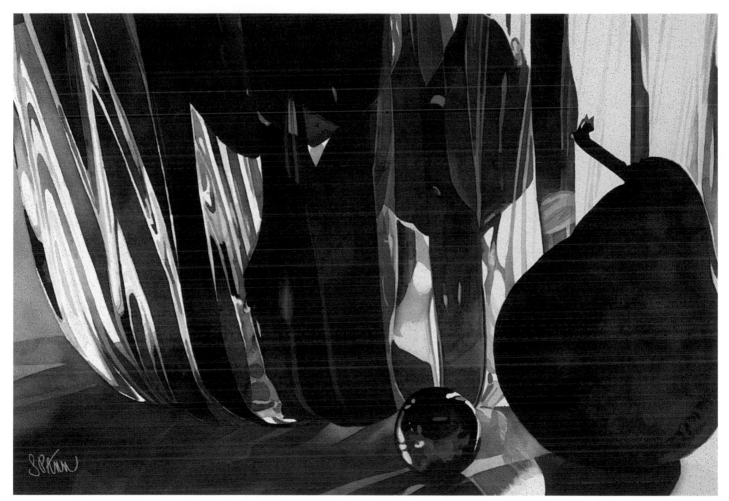

The majority of these values are **5** through **10**. The white of the paper gives sparkle and mystery.

About Face
Puzzle of Pears Series
40" x 60" (102cm x 152cm)
Collection of Nena and Hartley Rowe

VALUES ARE THE MUSIC OF A PAINTING

*I like to imagine that the values in my paintings are to my eyes as a symphony orchestra is to my ears. The **1**, **2** and **3** values are the delicate piccolos, while the **9** and **10** values are the rich violas and rhythmic bass violins. Each artist comes up with her own music and how she wishes to mix values.*

Painting Crystal With One Color

Lead crystal is a solid, heavy object. It's important that you build up your values when painting it, to give the glass the sparkle and depth needed to create dimension. Use hard edges to convey this marvelous texture. Hard edges and soft edges should be used throughout the painting of crystal to further give the perception of three-dimensionality.

In this demonstration, paint a champagne glass from life or a photograph, using values 1 through 10. This demonstration will not concentrate on color; we'll build up the glass like a black-and-white Polaroid.

MATERIALS LIST

- **Surface** 300-lb. (638gsm) rough watercolor paper
- **Paints** Payne's Gray
- **Brushes** Rounds: no. 1, no. 2
- **Other** Bounty paper towels
 Pencil

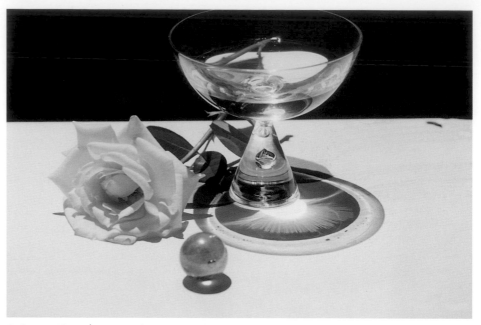

Reference Photo | Using a photo is a good way to start painting crystal, as the lighting will not waver.

Thumbnail Value Sketch | Set up light and dark patterns to make the crystal glass pop from the contrasts. Surround the edge of the glass with dark values.

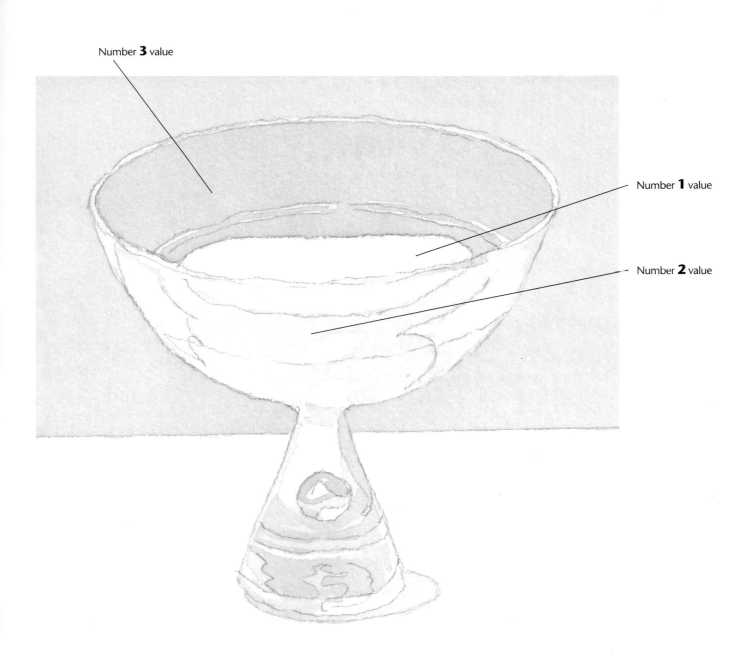

Number **3** value

Number **1** value

Number **2** value

1 **Establish the First Three Values** | Sketch the glass on your paper with a pencil. Leave the
lightest areas and highlights as the white of the paper. They are the number **1** value. Then use
your round no. 2 brush and Payne's Gray to mix a light number **2** glaze and apply it on all areas
except the number **1** area. Let dry. The hard edges will appear if the paper is thoroughly dry before
applying the next glaze. Paint the number **3** values in all areas except where you want **1** and **2** to
remain. Let dry.

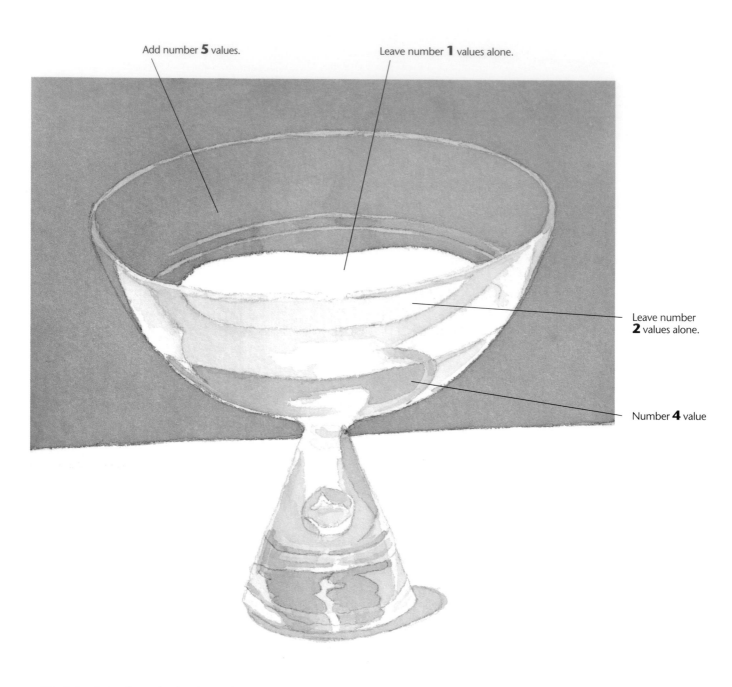

Add number **5** values.

Leave number **1** values alone.

Leave number **2** values alone.

Number **4** value

2 **Paint the Midtones** | After the number **3** value has thoroughly dried, mix a number **4** value and apply it over all the areas that should go darker. Do not paint over your **1, 2** and **3** values. Wait for your paint to dry and continue with a number **5** value glaze. Look at the photograph and use your value scale to help determine which value goes where. Each darker value takes up less space. Keep edges hard. Use the no. 1 brush when needed on smaller areas.

Add number **6** glaze over the rim.　　Number **7** value

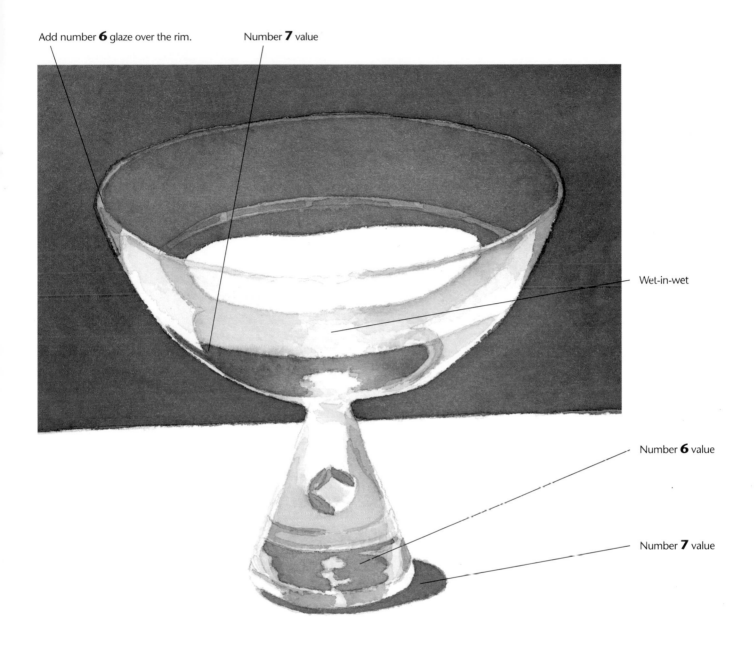

Wet-in-wet

Number **6** value

Number **7** value

3 **Paint the Next Two Values (6 and 7)** | These darker values help a three-dimensional effect
begin to emerge. To show liquid in crystal within a hard-edged area, use a wet-in-wet painting
method.

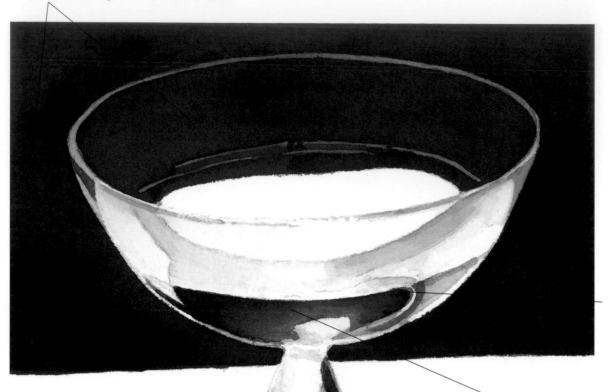

Darken the background with **8** and **9** values.

Add number **10** value on corners to help glass turn in space.

Number **9** value

4 **Add the Darkest Values (8, 9 and 10)** | This last step entails the least amount of painting on the glass object itself. Only a few number **9** and **10** values are needed or the glass will appear too heavy, so be careful. These values are needed to "polish" the crystal and make the glass come alive with sparkle and energy. There is a fine line between values **8**, **9** and **10**. The **10** value is added to the glass only, not the background, as you want the lightest light and darkest dark on the crystal itself. This helps the glass come forward to the viewer.

BUILD VALUES GRADUALLY

Don't let impatience cause you to add too much pigment to the darker value mixes or they may become opaque and shiny.

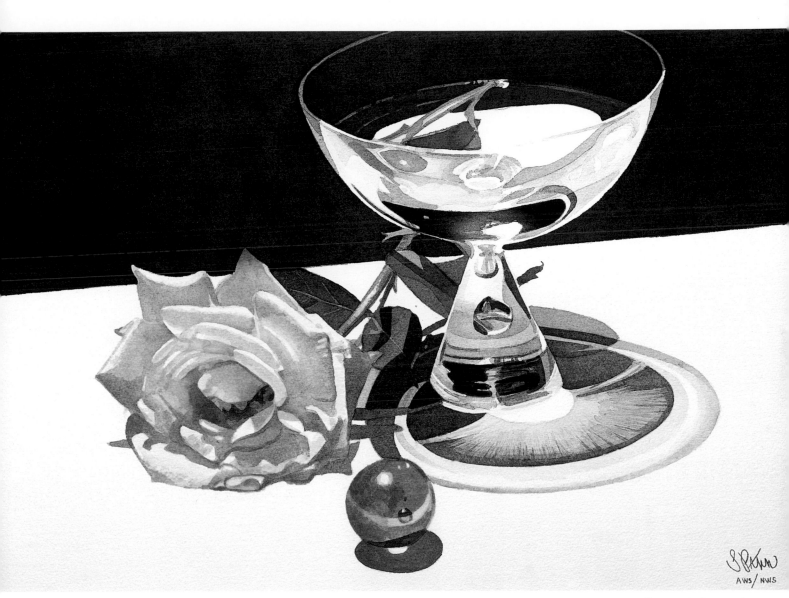

Summer in Savannah
13" x 20" (33cm x 51cm)
Collection of the artist

Solving Value Problems

The value scale and hard edges are wonderful tools. They will help you understand and solve the value problems you may have with your earlier paintings, those you may have sitting on the floor at home. Ask yourself some of these questions.

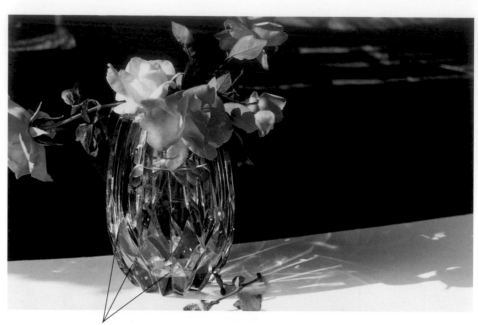

Needs whites to sparkle.

Did You Leave a 1 Value? | No true whites show up here, so a painting of this photo would lack life. To fix, lift out whites in the highlights and preplan whites the next time.

Are There Only 4, 5 and 6 Values? | If your paintings utilize only midtones, they can be dull and boring.

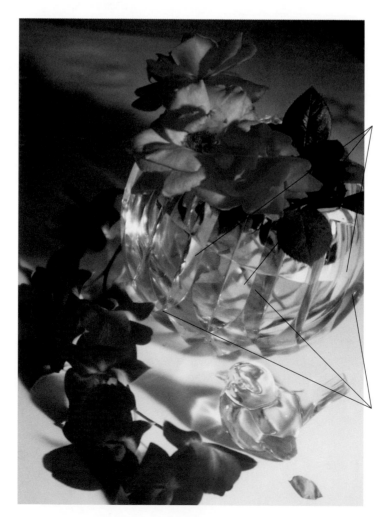

Lighter values needed.

Darker values needed.

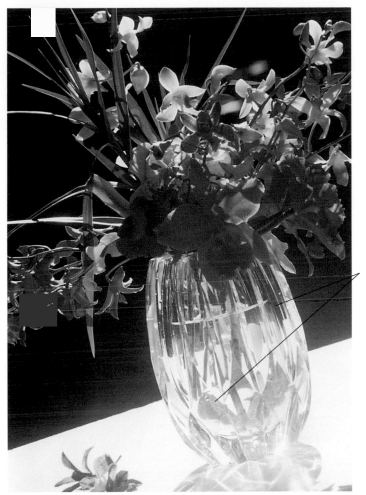

Areas to add darks

**Are There 8, 9 and 10 Values to Give
"Punch"?** | Paintings without darker values don't
have the energy or drama that comes from con-
trasting lights and darks.

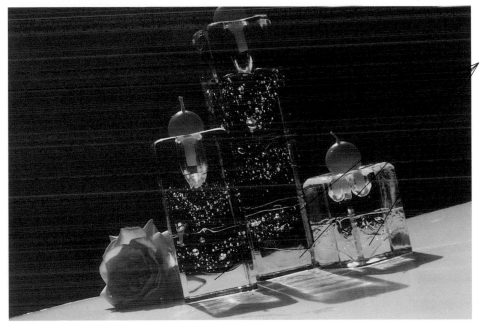

Areas that need
to be lightened

Are There Too Many 8, 9 and 10 Values? | Too many dark values can
overpower your subject.

3

Clarity of Composition

If value is the skeleton of painting, then composition is the muscle. For the enthusiastic artist, knowing what to paint is the easy part. The difficulty comes in composing the elements into an interesting, unusual, powerful or pleasing design. You can break the act of composition into three phases: setup, point of view and thumbnail. All three of these steps prepare the artist with tools that help make fewer mistakes and set the brain in motion for the actual placing of paint on paper. Preplanning has certainly helped me have more successes with the painting of crystal and flowers than just winging it.

Under the Rainbow
30" x 42" (76cm x 107cm)
Collection of Barbara Howard

Setting Up Your Composition

When choosing flowers and crystal to paint, look for contrasts. These contrasts can be in size: how large or small. They can be in temperature: how warm or cool. They can deal with textures: hard edged or soft edged. Or contrasts can occur in relationships, such as man-made vs. nature-made. After you have selected the contrasts you wish to use, try to arrange an odd number (3, 5, 7) of objects in your composition. This adds more interest to your design.

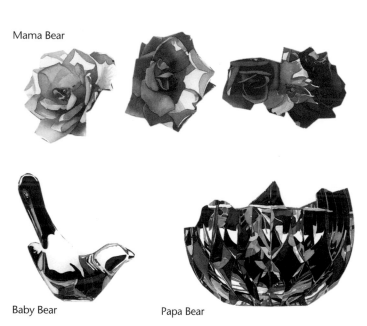

Mama Bear

Baby Bear

Papa Bear

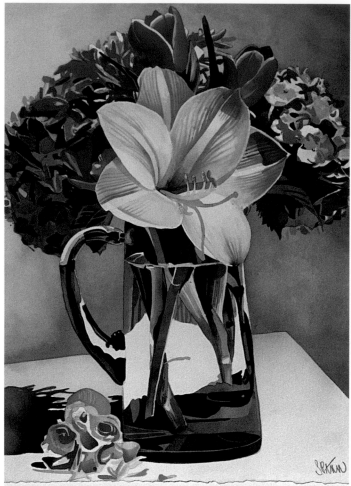

Size Contrasts | One of the techniques used for composing with clarity is to pretend your eyes are a pair of scissors. Visually cut out shapes from your design and "see" if they are compatible with various sizes. This relationship can be remembered by the family of Papa Bear, Mama Bear and Baby Bear (big, medium and small shapes).

Choose one large dominant object, such as a crystal pitcher, and embellish it with medium-size objects, like the beautiful flowers in this bouquet. These two sizes are then complemented by some small objects placed strategically in the composition. Look closely and you'll see that even the bouquet has big, medium and little flowers within it.

Sunday Tea Time
39" x 31" (99cm x 79cm)
Collection of Pam and Hank Hood

Determining Your Point of View

There are three points of view for composing crystal and flower still lifes: distant, middle and close up. Using a camera to compose your still lifes allows you to edit through the lens, finding the best point of view for each display of objects.

If you find it burdensome to carry a camera around, there is a way to always have a "camera" handy without ever taking it with you: Find a slide holder and press out the slide. This now becomes a camera lens. Put it in your paint box along with your value scale and other supplies.

Distant Point of View | Place the slide holder in front of one eye as if it were a pair of eyeglasses and view your still life. Look at everything that can be seen through the slide holder. Really see the bouquet, the table where it is placed and then the whole room. Perhaps a window opens into your backyard. Keep that in your view. A distant view gives importance to the environment in which your crystal and flowers have been placed.

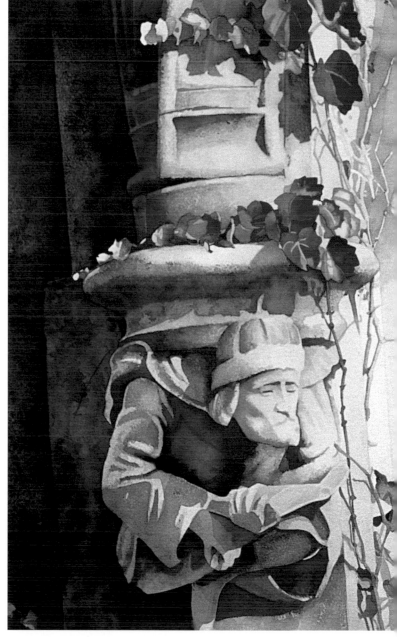

This composition sets up the foliage as an accent for a full view of the carved statuary and distant architecture.

Scholar in Autumn
40" x 30" (102cm x 76cm)
Private collection

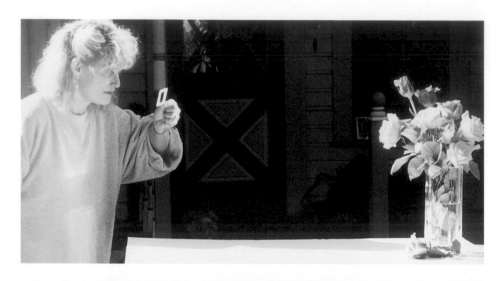

Middle Point of View | Now, still grasping the slide holder, extend your arm in front of you so your elbow is at a 45-degree angle. Look through the slide holder at your still life. This is the middle point of view and lets your eye take in the crystal bowl and flowers as well as part of the table with its cloth, shadow, etc. This is the most popular point of view for still lifes. It gives importance to the beauty of the crystal object and to the flowers within the setup.

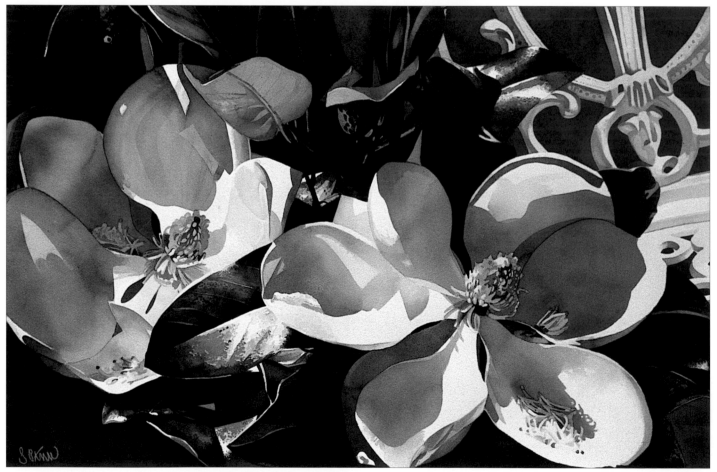

The two large magnolias fill the majority of the composition. The leaves on the left begin the curve of the flowers which ends with the curve of the garden chair. Smaller shapes are introduced with the promise of the magnolia bud and the dropped stamens in the cupped petals.

April's Promise
35" x 55" (89cm x 140cm)
Collection of Lynn and Jeff Shaara

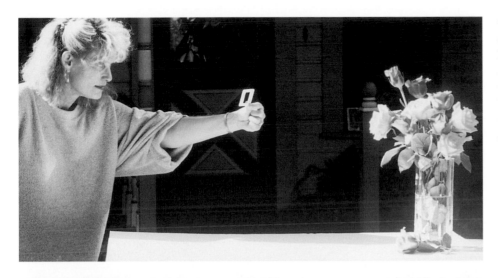

Close Point of View | This time, stretch your arm out full length with the slide holder and look at the still life. This point of view allows the artist to really see the intricacies of the flower or the abstract quality of the crystal. Small objects become abstract when blown up. A close point of view gives importance to these small objects, making them appear more dramatic.

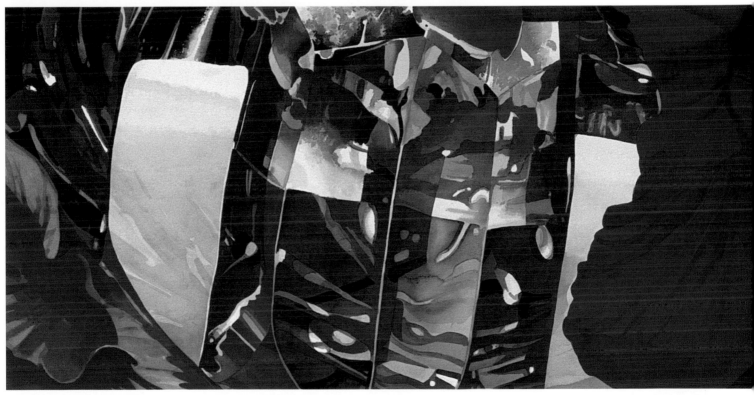

The close-up of the crystal facets becomes a group of rhythmic shapes. The hibiscuses repeat themselves adding to the swirling movement and tension.

Anticipation
40" x 60" (102cm x 152cm)
Collection of Sharon and Dick Williams

Creating Thumbnail Sketches

Thumbnail sketches are just your own shorthand and nothing more. Use them to create value patterns and to rearrange objects in the composition for better movement of eye flow. I cannot encourage you enough to make thumbnails before ever beginning a painting of crystal and flowers. So many mistakes are caught at this stage and corrected with minimal time and effort, not to mention the saving of money in supplies!

Thumbnails need not be large or costly in time. Keep them small; sometimes as small as the interior of a slide holder will work. I use a fine-line Pentel felt-tip pen to make my sketches, as it makes a great dark value. You can purchase a Pentel pen at any office supply store. However, a ballpoint pen or pencil does the same job. Many artists do prefer a pencil, but a black Pentel pen gives the true feeling of darker values as opposed to a pencil's light grays. You can use any type of paper—a sketchbook, napkin, whatever is handy.

Problem Setup | The area on the right of this photo is too busy and cluttered.

Value Sketch | The value sketch helps you see if the painting will be too cluttered.

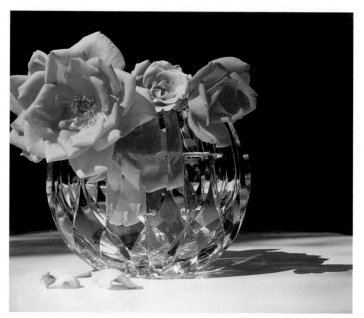

Problem Setup | The subject is cramped in this photo.

Thumbnail Sketch | The thumbnail sketch helps you rearrange so the subject has more space around it.

Distant Point of View | The background and foreground are equally important. The magnolias sitting on the chair are an accent.

Distant-View Thumbnail

Middle Point of View | The magnolias and their leaf patterns are the most important. The background is only a negative space.

Middle-View Thumbnail

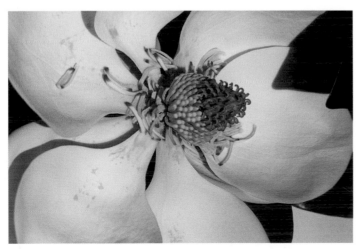

Close Point of View | This view centers on the magnolias and their glorious shapes and shadows. Look at your sketches. Which is most appealing as a future painting? Why do you feel this way?

Close-View Thumbnail

Designing With Contrasts

There are several other contrasts that may be used in your paintings: positive/negative, simple/complex, symmetrical/asymmetrical and busy/open. Whether you're speaking of people or paintings, at any one time, one partner is giving (or taking!) more than 50 percent! Each side of the contrast should be composed with varied percentages of power in different paintings.

LESS IS MORE

People are always saying how lovely my Waterford crystal paintings are, but they are not Waterford. While Waterford crystal vases are certainly beautiful, they have about a jillion Xs in their designs and are a mishmash to paint. Please choose something clear, almost boring, for the first few tries. You obtain confidence and later get bolder painting facets that are a tad more intricate.

Weak

Strong

Positive and Negative Shapes | Become a pair of scissors and cut out both the positive and the negative shapes. Are they compatible? Are they too equal in power? Has one covered too great a percentage of the paper, creating an off-balanced appearance? Do they help one another or detract from each other? Your thumbnail sketches are the greatest help here. Use them to help you direct your stage performers around to attain the best visual composition.

Complex

Complex and Simple | In a crystal composition, complexity may include too many facets on the crystal, too many objects around the crystal, or too many color combinations in the crystal. The more simple the glass object is, the better the chance of making a successful painting.

Simple

Symmetrical

Asymmetrical

Symmetrical and Asymmetrical | Symmetrical compositions have equal power or weight of objects on each side. The design can be visually cut down the middle and each side is the same. Symmetrical compositions tend to be formal with a sense of stability, predictability and tranquility.

Asymmetrical compositions have the same weight or power as the symmetrical designs, but the weight has been shifted to be uneven or irregular. Asymmetrical compositions tend to be informal with a sense of randomness and unpredictability, and are more interesting.

Busy

Busy and Open | When composing with clarity, think of areas in your designs that are very busy with many shapes, varied textures or numerous colors, for example. The eye can become overwhelmed with all of this information.

Give the eye a place to rest. Leave a space in the composition that is just "open" and quiet, such as a background, a wall or white fabric. This open space gives the eye a chance to catch its breath, gather its thoughts and move back into the painting for more information.

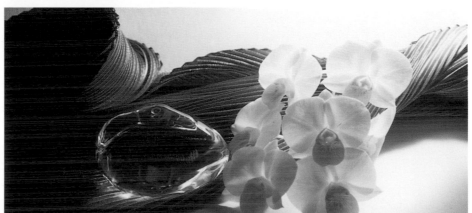

Open spaces

Types of Compositions

There are all types of compositions and the way an artist uses them becomes part of her particular style. This section introduces the "letter compositions" that I use in my work.

Bleed

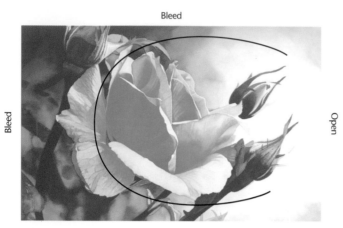

Bleed

Bleed

Open

The C Composition | This one is my personal favorite. A C composition is where paint touches or bleeds off three sides of the watercolor paper but not the fourth; it remains the white of the paper. The letter **C** may face upward as if it were a **U**, or face either side of the paper. Using this composition encourages the white of the paper to have a lost edge. The paint appears to evaporate from a **2** value into a **1**. To help you remember this concept, "make a place for the birds to fly in and the birds to fly out."

Sentimental Journey
30" x 40" (76cm x 102cm)
Collection of Donna and Jon Burrichter

Top of T

Stem

The T Composition | This composition has the main elements of the painting positioned along a horizontal line, like the top of the **T**. It then has an anchor area or stem in the middle or off center. You can also position it as an upside-down **T**.

Northern Lady
23" x 13" (58cm x 33cm)
Collection of Nancy Schleicher

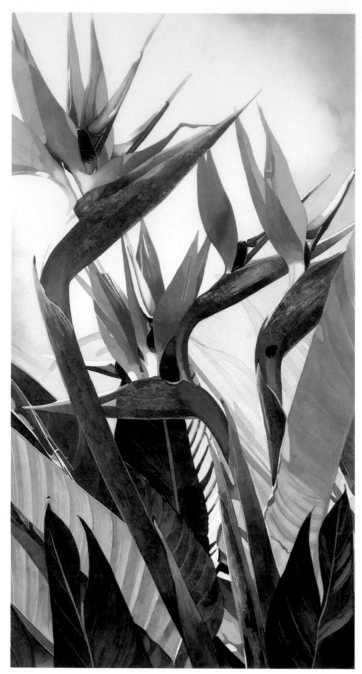

Inside Eden
60" x 40" (152cm x 102cm)
Private collection

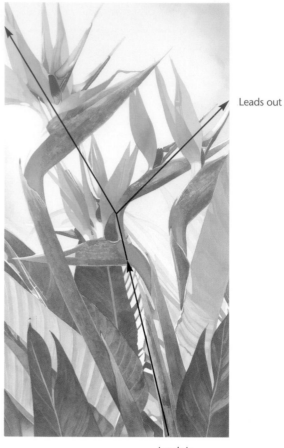

Leads out

Leads in

The Y Composition | The Y composition is like the **T**, except with more of an angle from the horizontal lines. This composition leads the eye into a painting and then takes it out. You can also use this composition upside down or sideways. Think of it as a road map.

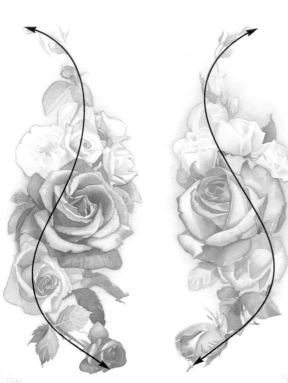

Backward S Forward S

The S Composition | This composition is very graceful and can be designed with a mate for a matching pair of paintings. The **S** may be forward or backward. The important elements should follow the curve of the letter **S**.

Jewels of June (far left)
30" x 19" (76cm x 48cm)
Collection of Barbara and Bill Cloche

Gems of July (near left)
30" x 19" (76cm x 48cm)
Collection of Barbara and Bill Cloche

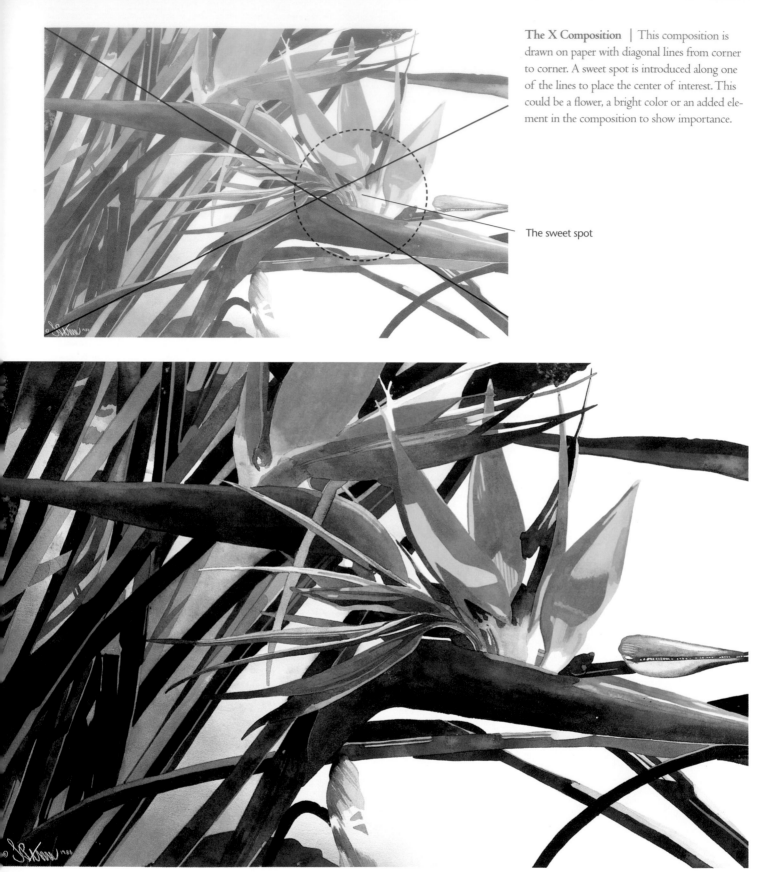

The X Composition | This composition is drawn on paper with diagonal lines from corner to corner. A sweet spot is introduced along one of the lines to place the center of interest. This could be a flower, a bright color or an added element in the composition to show importance.

The sweet spot

Gemini
30" x 40" (76cm x 102cm)
Collection of Jackie Sinett

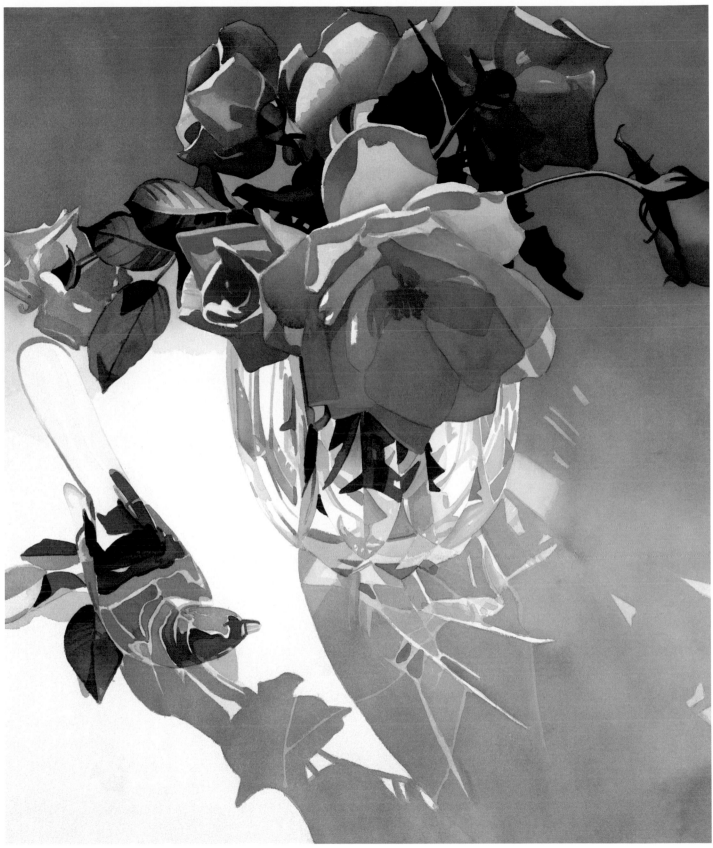

Perspective Composition | You can construct a composition that takes the viewer to an unusual place for the eye. This painting has a bird's-eye view. The viewer is looking down at the subject.

Sundowner's Blues
35" x 31" (89cm x 79cm)
Collection of Green Bridge Association

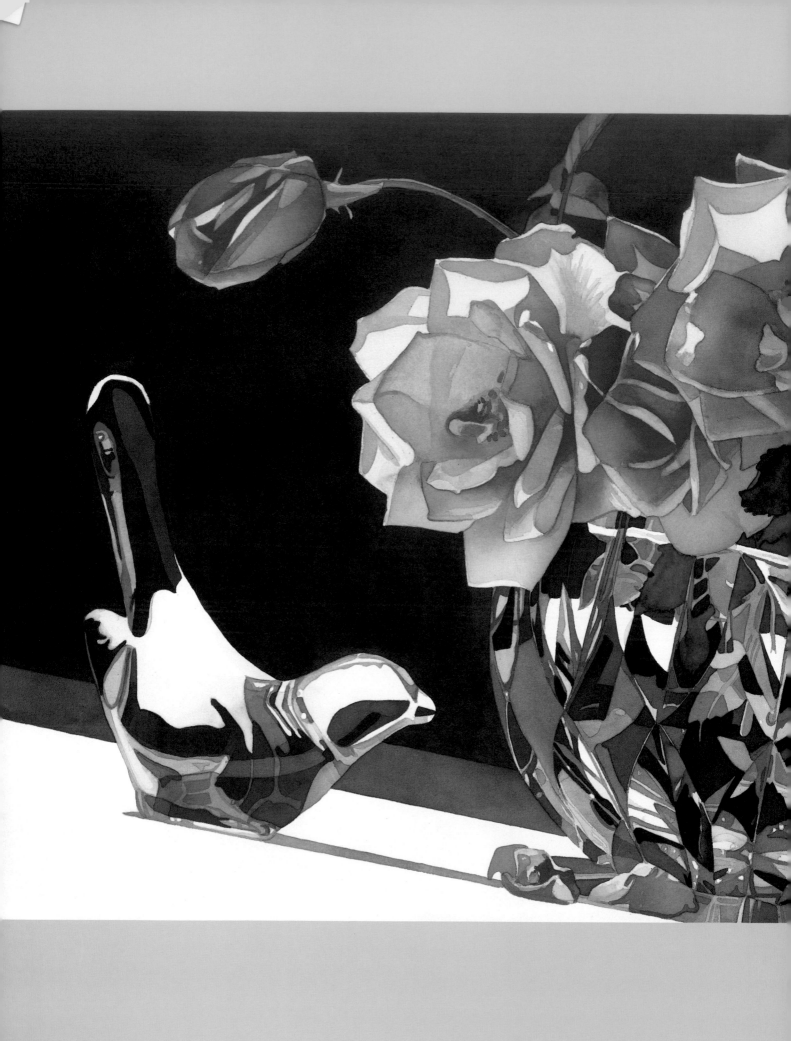

Charisma of Color

If value is the skeleton of painting and composition the muscles, then color is truly the soul! Color can add brilliance or evoke melancholy. It can depict joy or communicate seriousness. An artist's choices of color can become his signature. Just look at Andrew Wyeth and his earth palette. Interior designers apply the psychology of color to environments to give a sense of poshness, tranquility or casualness, for example. Volumes have been written just on color, and it's certainly my favorite element! It's also a very personal part of a painting, and the choices open to the watercolorist are overwhelming at times. In this chapter I will touch on only a few of these hundreds of options. I have included color exercises to practice and play with in your studio.

Gypsy Souls With Wings of Gold
32" x 45" (81cm x 114cm)
Collection of Laura and Edwin Waler, Jr.

DEMONSTRATIO

Painting color wheels can be a fun learning experience. Separating your wheels into color families will help you create a composition with a limited palette.

It's not hard to make a color wheel. You can use any three primaries. Sound too simple? Just choose any paint with the color red in the pigment. Then do the same for your yellow and blue. The combinations you'll explore and discover will be fascinating.

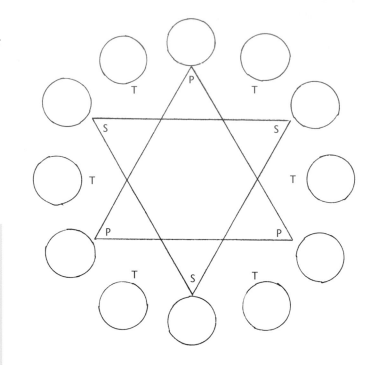

MATERIALS LIST

- **Surface** 7″ × 7″ (18cm × 18cm) square of 300-lb. (638gsm) rough watercolor paper

- **Paints** Transparent Yellow
 Ultramarine Turquoise
 Winsor Red

- **Brushes** Round: no. 1 or no. 2

- **Other** Bounty paper towels
 Pencil
 Quarter
 Triangle template (you can make yourself a 4″ × 4″ × 4″ [10cm × 10cm × 10cm] triangle from a piece of watercolor paper) or a ruler

1 **Draw Your Template** | Draw a triangle on your paper with a ruler or from your template. Make a circle at the end of each point with a quarter and label each circle with a **P** for primary colors (yellow, red and blue). Draw a second triangle upside down on top of the first. Make circles on the points of that triangle and label with an **S** (secondary colors). Make circles between all the points and label those with a **T** (tertiary colors). There will be twelve circles when you are finished.

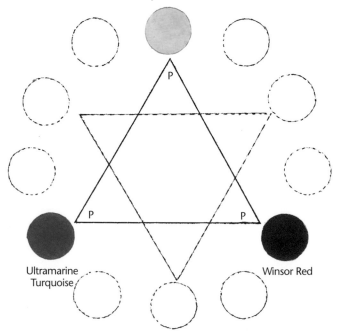

2 **Paint in Your Primaries** | Place the yellow at the top of any color wheel you make. This will help later when you may need to compare color schemes. Select a yellow and paint it rather thickly in the top circle. Thoroughly clean your brush before going into the next color. Select a red and place it as the right primary. Clean the brush and water. Select a blue and place it as the left primary. Label with color names.

3 **Paint in Your Secondaries** | Mix yellow and red to obtain an orange. Place it between the yellow and red. Clean your water and brush. Mix the yellow and blue to get a green, and place it between the yellow and blue. Clean the water and brush. Mix the blue and red to make a purple. Place it between the blue and red.

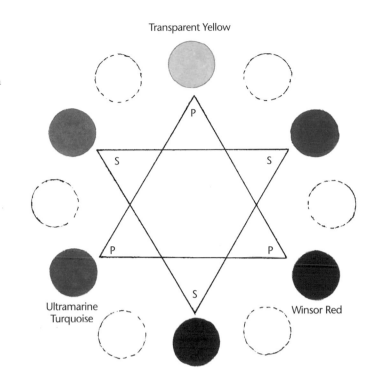

4 **Finish Up With Tertiaries** | Mix yellow with orange to obtain a yellow-orange. Place in circle. Mix red with orange to get a red-orange. Place in circle. Clean water and brushes. Mix red and purple to obtain a red-purple. Place in circle. Mix blue and purple to create blue-purple. Place in circle. Clean water and brushes. Mix blue with green to obtain blue-green. Place in circle. Mix yellow with green to get a yellow-green. Place in circle.

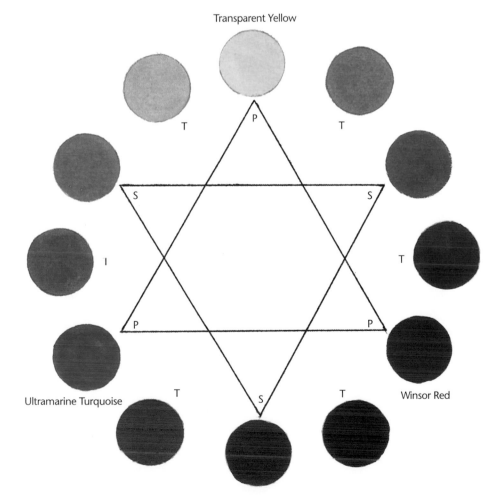

Color Families and Schemes

Think of color families and schemes as formulas for your colors to work together in different combinations.

Color Families

A color family has three primary colors in common with all of the rest of its colors.

This is much like DNA in a human family. Because of these common primaries, there is a "look" to the painting.

Color Schemes

Color schemes are combinations of colors that have worked together for a long time, much like friends. Well-known color schemes are "complementary" (across from each other on the color wheel), "analogous" (neighbors with each other on the color wheel), "warm" (the warm colors on the color wheel) and "cool" (the cool colors on the color wheel).

Warm Family | Use a color wheel made from Cadmium Yellow Pale, Permanent Rose and Cobalt Turquoise to paint sunlit scenes.

Cool Family | Use a color wheel made from Winsor Yellow, Crimson Lake and Prussian Blue to paint shadowy scenes or cool evening pieces.

Southwest Family | Use a color wheel made from Yellow Ochre, Burnt Sienna and Cerulean Blue to create a dusty, earthy emotion in your paintings.

Tropical Wheel | Use a color wheel made from Indian Yellow, Cadmium Scarlet and Cobalt Turquoise Light to paint flowers from the tropics to give a bright, colorful feeling to your painting.

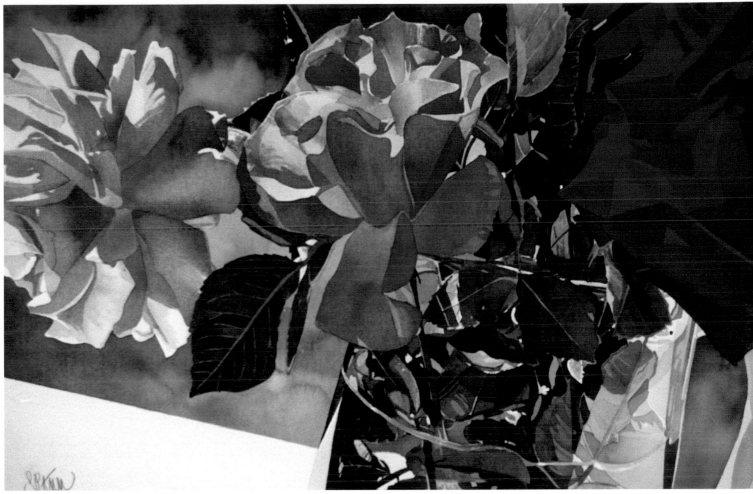

Complementary Color Scheme | Warm and cool reds and greens are used throughout this painting.

Sisters of Summer
40" x 60" (102cm x 152cm)
Collection of Patricia Schmidt

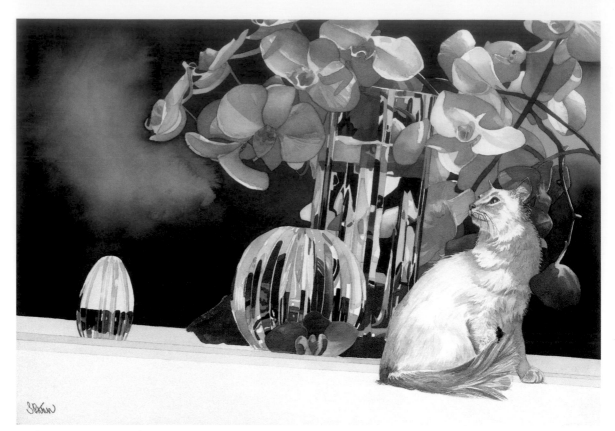

Analogous Color Scheme | Analogous colors are used in the shadows in the orchids and the cool tones in the cat's fur.

Beauty From Bali
32" x 40" (81cm x 102cm)
Collection of Mary Kate and Robert Harrison

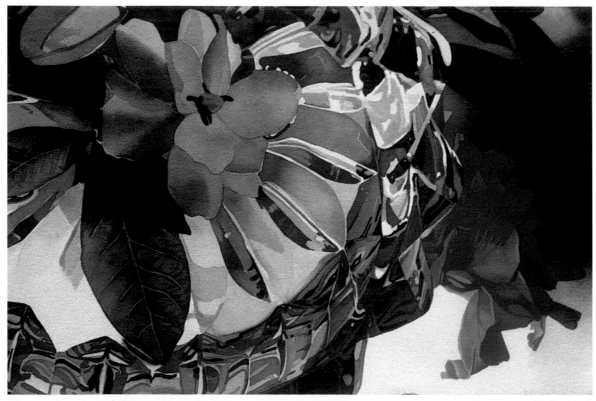

Warm Color Scheme | Warm colors make this painting luminous and alive.

Summertime in the South
15" x 30" (38cm x 76cm)
Collection of Dr. Tom Campbell and Dr. Mary Gerodetti

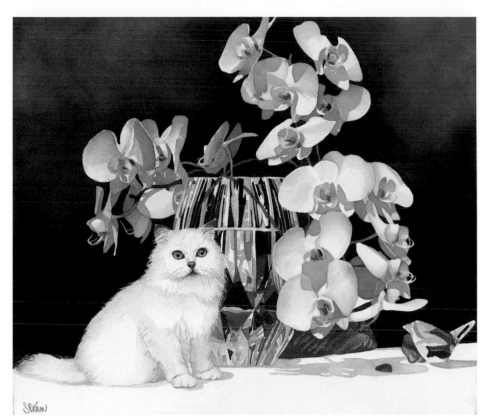

Cool Color Scheme | This painting is structured as a cool pyramid portrait.

Chin' an' Chick
35" x 45" (89cm x 114cm)
Collection of Nancy Schleicher

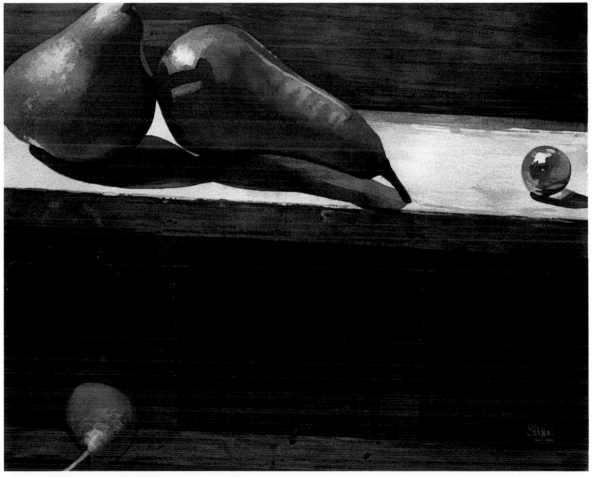

Earth Color Scheme | The colors used in this painting produce a warm, homey feeling.

Pinwheels of Pears
35" x 45" (89cm x 114cm)
Collection of Laura and Dick Irwin

Color Mixing to Give Dimension

For crystal to look three-dimensional, a variety of values and colors need to be mixed. Most colors need some help to become darker, warmer or cooler. I call these helpers "agents." Agents are various colors that, when mixed with another color, will change it. To apply this concept, you darken values with darkening agents and you warm or cool colors with warming or cooling agents.

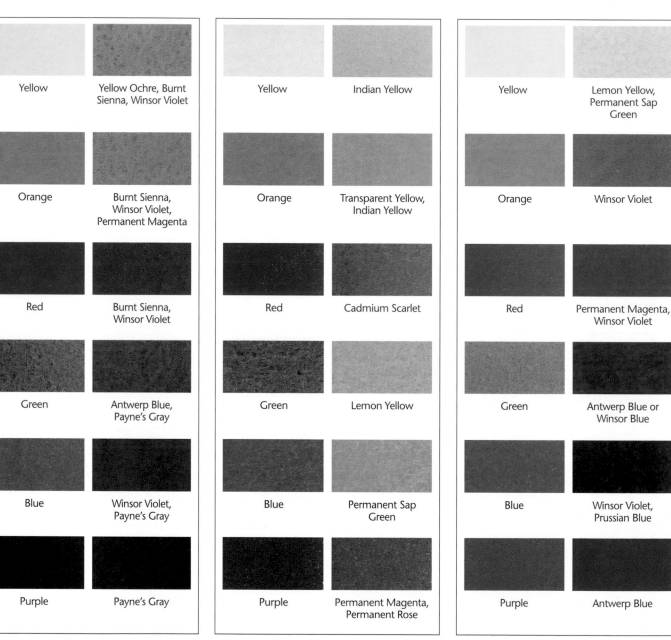

Yellow	Yellow Ochre, Burnt Sienna, Winsor Violet	Yellow	Indian Yellow	Yellow	Lemon Yellow, Permanent Sap Green
Orange	Burnt Sienna, Winsor Violet, Permanent Magenta	Orange	Transparent Yellow, Indian Yellow	Orange	Winsor Violet
Red	Burnt Sienna, Winsor Violet	Red	Cadmium Scarlet	Red	Permanent Magenta, Winsor Violet
Green	Antwerp Blue, Payne's Gray	Green	Lemon Yellow	Green	Antwerp Blue or Winsor Blue
Blue	Winsor Violet, Payne's Gray	Blue	Permanent Sap Green	Blue	Winsor Violet, Prussian Blue
Purple	Payne's Gray	Purple	Permanent Magenta, Permanent Rose	Purple	Antwerp Blue

Darkening Agents | Darkening agents make the original hue darker. This concept can be used when a flower is in shadow or has a darker color. Mix your darkening agents to get the desired glaze. The glaze is then applied over the original color. (Here, the pure colors are on the *left*, and the darkening agents added to the pure colors are on the *right*.)

Warming Agents | These pigments are added to make your original color warmer. They would be used when a flower is in sunshine or bright light. Warm colors come forward to the viewer. (Here, the pure colors are on the *left*, and warming agents added to the pure colors are on the *right*.)

Cooling Agents | Add these pigments to give a coolness to your color. Use them in shadows, on petals and leaves to push them behind forward flowers. Cool colors recede from the viewer. (Here, the pure colors are on the *left*, and the cooling agents added to the pure colors are on the *right*.)

Using Base Colors

To give a certain emotion or overall tempera-
ture to a painting, you can mix a small
amount of one pigment with each color as
you paint.

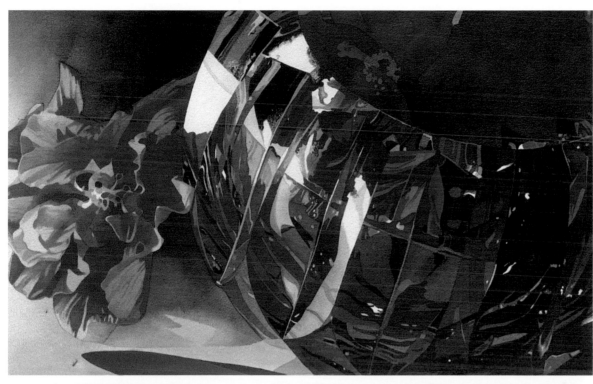

Yellow Ochre is the
base color used here
to make the glass
warmer.

Tapestry in Glass
40" x 60"
(102cm x 152cm)
Collection of
Dianne Kinney

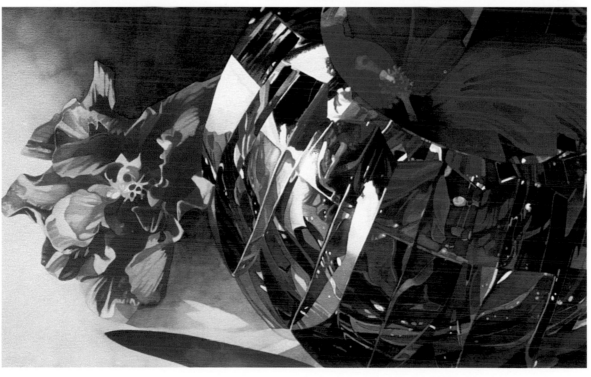

Antwerp Blue is the
base color used here
to make the glass
cooler.

*When Deep
Purple Falls*
40" x 60"
(102cm x 152cm)
Collection of Linda
Verbeten-Whitby

The Color of Clear Crystal

Crystal and glass have their own color, even though they appear absolutely clear to the eye. They are not invisible, but a smoky gray. You can create this warm gray by mixing Payne's Gray and Yellow Ochre. (If the glass has a cool hue, add some Antwerp Blue.) This mixture of paint becomes extremely transparent by adding about 90 percent water to 10 percent pigment. In this demonstration, the glass will look much like the *"Painting Crystal With One Color"* demo from chapter two *(pages 32-36)*.

Materials List

- **Surface** *300-lb. (638gsm) rough watercolor paper*

- **Paints** *Payne's Gray*
 Yellow Ochre

- **Brushes** *Rounds: no. 0, no. 1, no. 2, no. 4*

- **Other** *Bounty paper towels*

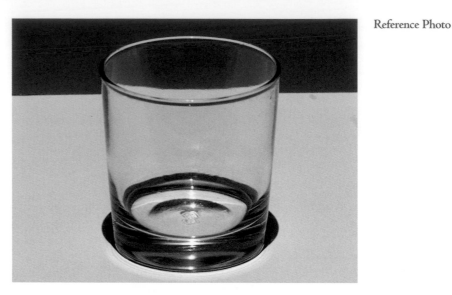

Reference Photo

Value **1** Value **2**

Value **3**

Value **1**

1 **Plan Your Values and Begin Painting** | Plan the location of the number **1** values in the crystal drinking glass and leave them alone. Mix a glaze with Payne's Gray and Yellow Ochre. Make it lighter even than the color of weak tea. It will look like a smoky gray. Paint this as value **2** over the glass and background, with the exception of the value **1** areas, starting with a no. **1** brush on the glass edge and filling in larger areas with a no. 4 brush. Let dry.

Then mix a value **3** glaze by adding a bit more Payne's Gray to the mix, painting the rim of the glass and bottom bands using the no. **1** or no. **2** brush and filling in with the no. 4. Let dry.

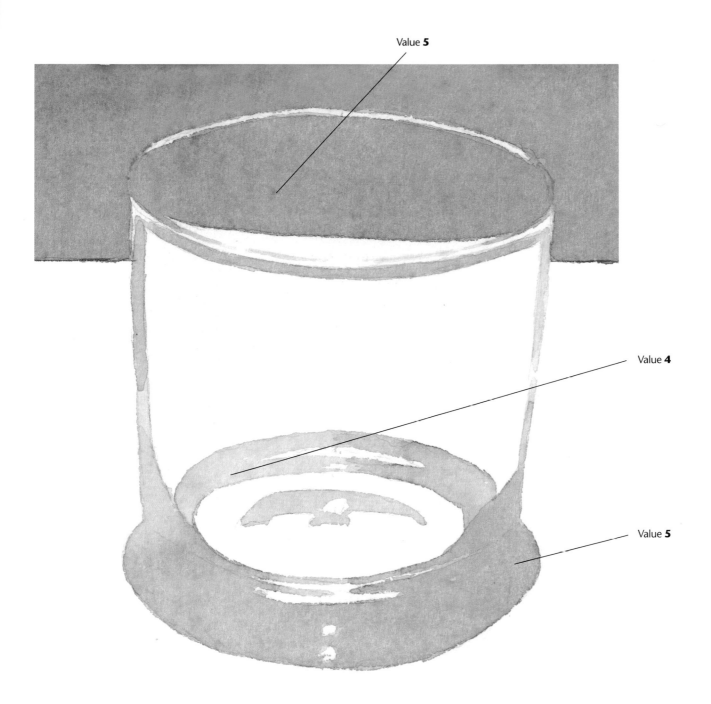

Value **5**

Value **4**

Value **5**

2 **Continue Building Values** | Make your gray glaze a dollop darker with your paints and use your no. 1 or no. 2, and your no. 4 brushes to paint on the value 4 glazes over the edges and bottom bands of the glass. Let dry, then go a step darker with a value 5 glaze and paint this glaze over the background and the edges and bottom bands of the glass. Dab with a paper towel if edges start to get fuzzy due to not being dry. Let dry.

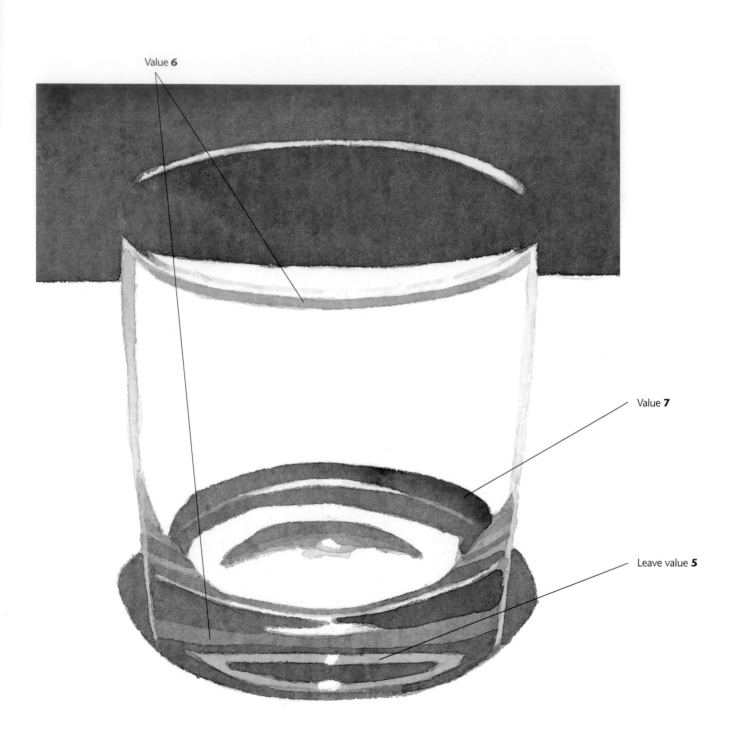

Value **6**

Value **7**

Leave value **5**

3 **Go Even Darker** | Mix a value 6 glaze and use your no. I brush to paint in the edges and various bands on the glass. Let the paint fuse with water on the outside edges of the glass, to help soften edges and turn the glass in space. Leave some of the number 5 values alone. Let dry.

Then, mix a value 7 glaze to paint on the background with your no. 4 brush. Use this same glaze and a no. 2 brush to paint in the bottom bands of the glass. Again, add a bit more water to the glaze on the outside edges of the glass to give it dimension. Leave bands of value 6 alone in bottom of glass. Let dry.

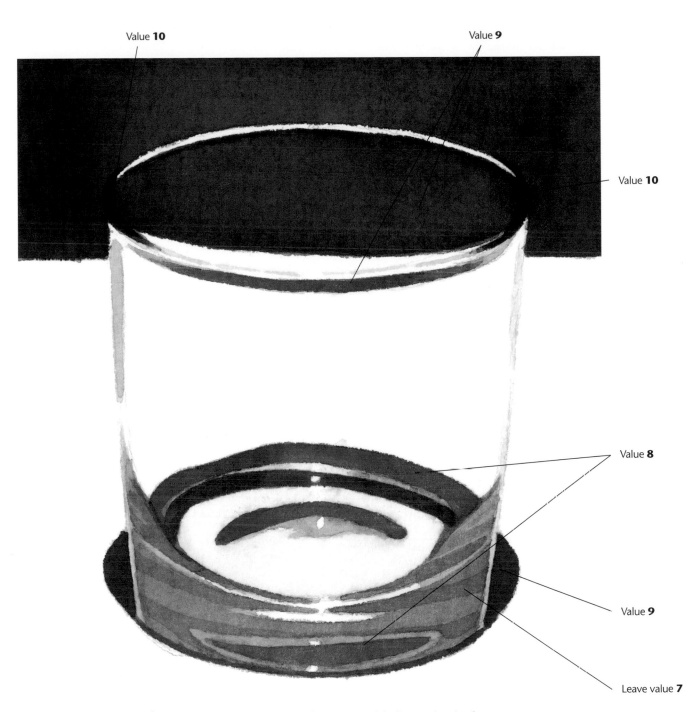

Value **10**

Value **9**

Value **10**

Value **8**

Value **9**

Leave value **7**

4 **Add Darkest Darks** | Mix a value **8** glaze and paint in the top rim and the bottom bands of the glass with your no. 0 brush. Paint the background with this same glaze and your no. 4 brush. Let edges soften along outside of glass. Leave some value **7** areas in the glass alone. Let glazes dry.

Then mix a value **9** glaze, painting in the rim of the glass, the shadow and some of the bands at the bottom of the glass with your no. 1 brush. Then paint the background with this glaze and your no. 4 brush. Let edges soften along the outside of the glass. Let dry.

Use Payne's Gray straight from the tube as your value **10**. Paint this value along the top rim of the glass with your no. 0 brush. Let dry.

CREATE COLOR FROM IN FRONT OF CRYSTAL

Clear crystal by itself is fairly boring. Adding color to it makes it come to life. Place an object in front of a crystal glass and the object reflects back into the glass, giving the glass subtle color changes.

MATERIALS LIST

- **Surface** *300-lb. (638gsm) rough watercolor paper*
- **Paints** *Indian Yellow*
 Payne's Gray
 Permanent Sap Green
 Winsor Red
 Yellow Ochre
- **Brushes** *Rounds: no. 0, no. 1, no. 2, no. 3*
- **Other** *Bounty paper towels*

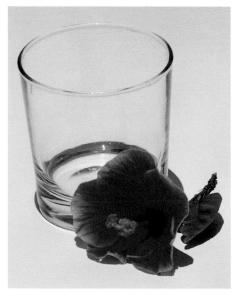

Reference Photo

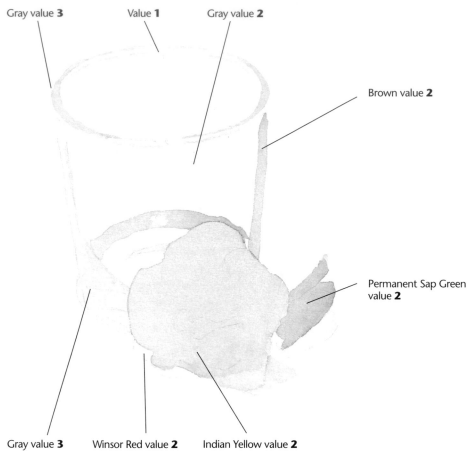

Gray value **3** Value **1** Gray value **2**

Brown value **2**

Permanent Sap Green value **2**

Gray value **3** Winsor Red value **2** Indian Yellow value **2**

1 **Plan Your Values and Begin Painting** | Mix a glaze from Payne's Gray and Yellow Ochre with your no. 3 brush. It will be a smoky gray. Mix another glaze from Winsor Red, Permanent Sap Green and Payne's Gray. This brownish glaze will be the reflected red of the hibiscus.

Plan the location of the number **1** values and leave them alone. Paint value **2** gray glazes with a no. **1** brush over the glass, with the exception of the value **1** areas. Let dry.

Use the no. 2 brush to glaze Indian Yellow over the flower and leaf. Let dry.

Mix a value **3** gray and paint the corners of the glass and the ellipses at the bottom of the glass with a no. 0 brush. Paint this value as the leaf's shadow.

Use your brownish glaze and your no. 0 or no. **1** brush to paint a value **2** brown as the thin bands on the rim of the glass and as the top ellipse at the bottom of the glass, as well as on the flower's shadow area on the right and the right edge of the glass.

Paint a value **2** Winsor Red glaze with your no. **1** brush as the flower's shadow on the left. This is the shadow's ambient color from the flower.

When the leaf is dry, paint it a value **2** green, by adding Payne's Gray to your Permanent Sap Green.

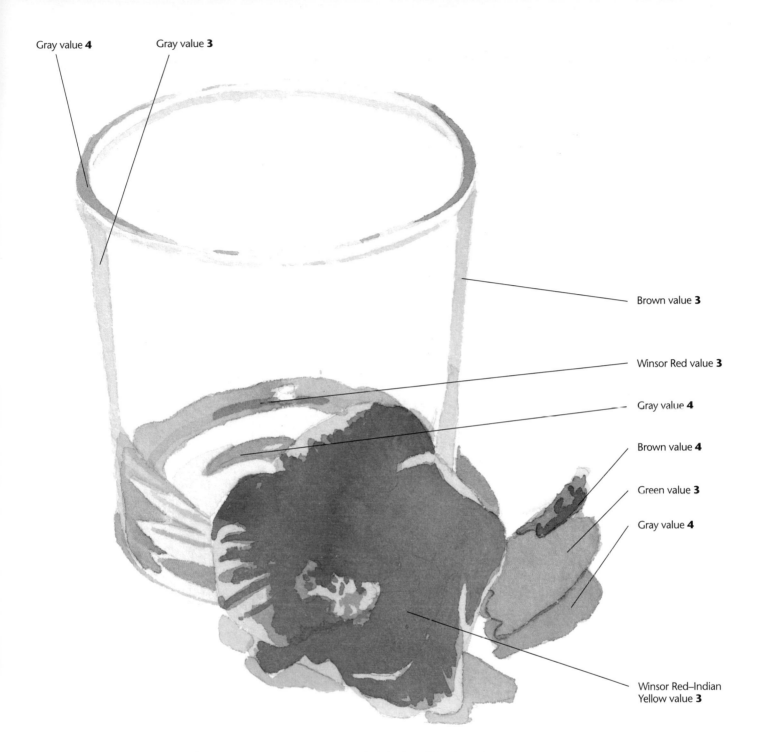

Gray value **4**　　Gray value **3**

Brown value **3**

Winsor Red value **3**

Gray value **4**

Brown value **4**

Green value **3**

Gray value **4**

Winsor Red–Indian
Yellow value **3**

2　**Continue Building Values** | Mix a gray value **3** glaze and paint the left edge of the glass. Mix a brown value **3** glaze and paint the right edge of the glass and the ellipse at the glass bottom. Mix a value **3** glaze from Winsor Red and Indian Yellow and paint the flower with your no. 2 brush, leaving some of the Indian Yellow showing at the edges to help turn the flower in space. Use this same glaze to paint a small section of the glass bottom and the flower's shadow on the right with your no. I brush. Mix a green value **3** and glaze the leaf. Let all this dry.

Mix a gray value **4** glaze and paint the corners of the glass's rim, as well as the shadows of the glass and leaf with your no. 0 brush. Paint in some triangular shapes at the bottom of the glass with this value to help turn the glass in space. Let dry.

Use your no. 0 or no. I brush to paint the stem of the leaf with a value **3** brown, then let dry and paint a value **4** brown over that to give it form.

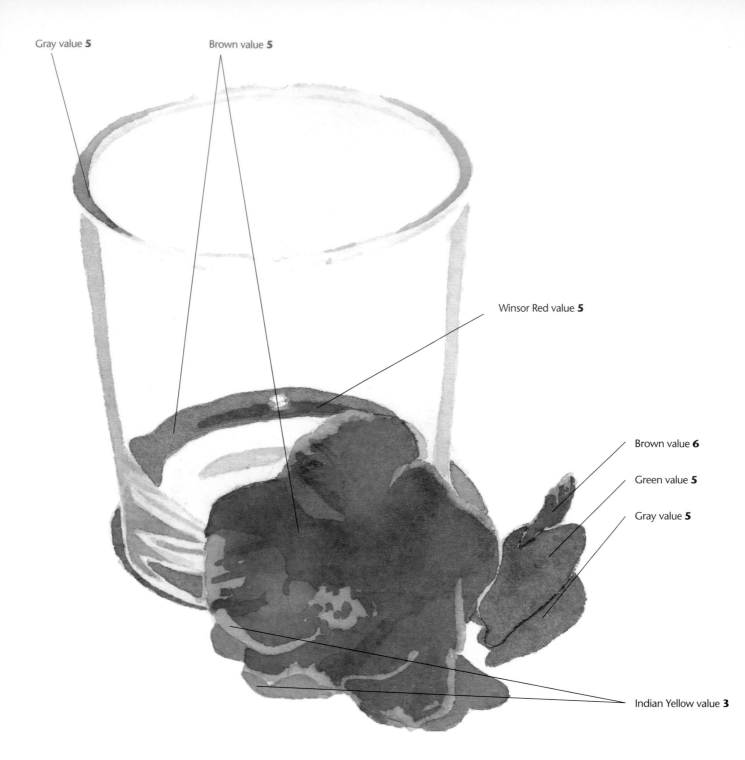

Gray value **5**

Brown value **5**

Winsor Red value **5**

Brown value **6**

Green value **5**

Gray value **5**

Indian Yellow value **3**

3 **Go Even Darker** | Paint a value **3** Indian Yellow over the flower and left shadow areas with your no. 2 brush to enrich the golden color. Mix a gray value **5** and paint the corners of the glass's rim, the left shadow of the glass and the leaf shadow. Also darken some of the triangular shapes in the bottom of the glass with your no. 0 or no. 1 brush. Mix a brown value **5** glaze and use your no. 1 brush to paint the ellipse in the bottom of the glass as well as the shadow area within the flower. Paint a value **5** green glaze over the leaf. Let dry then paint a value **6** over the stem of the leaf with your no. 0 brush and let dry. Paint a Winsor Red value **5** glaze with your no. 1 brush to darken the small reflected area in the glass bottom.

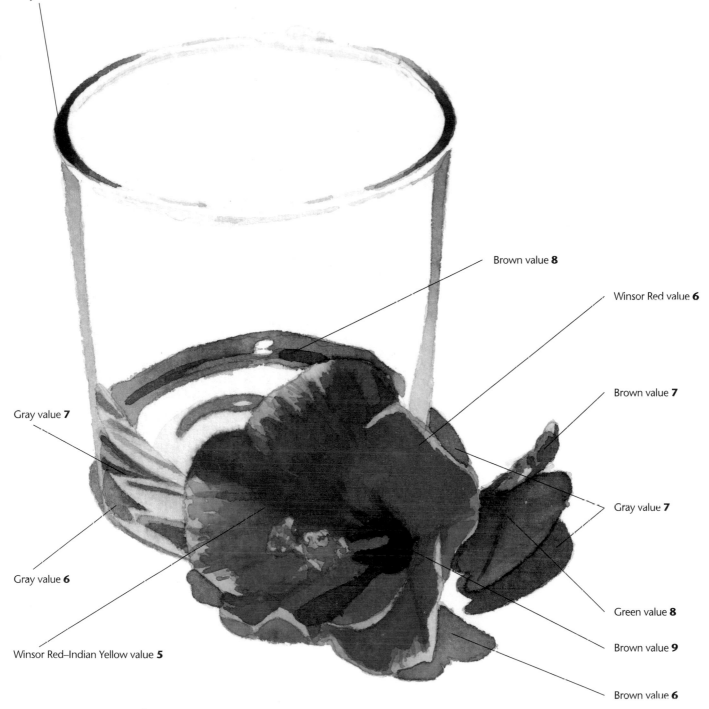

Gray value **10**

Brown value **8**

Winsor Red value **6**

Brown value **7**

Gray value **7**

Gray value **7**

Gray value **6**

Green value **8**

Brown value **9**

Winsor Red–Indian Yellow value **5**

Brown value **6**

4 **Add Darkest Darks** | Use your no. 2 brush and a Winsor Red–Indian Yellow value **5** glaze to paint the left side of the flower to add warmth. Paint a Winsor Red value **6** on the right side of the flower to give that side some coolness. Paint a gray value **6** in the triangular areas on the glass bottom. Paint a brown value **6** on the flower shadows. Let all this dry.

Paint a gray value **7** over the triangular areas in the glass, the glass shadow and the leaf shadow. Use a value **7** brown with your no. 0 or no. 1 brush to paint the leaf stem and more shadows in the flower. Let dry.

Glaze a value **8** green on the leaf using a wet-in-wet technique, showing some veins for interest. Paint a value **8** brown in the center of the ellipse on the glass bottom. Let dry. Use your no. 0 or no. 1 brush and a value **9** brown to paint the center of the flower.

Use your no. 0 brush to paint pure Payne's Gray as a value **10** on the corners of the glass's rim.

CREATE COLOR FROM INSIDE CRYSTAL

You can add dimension and interest to your crystal by placing objects (water, rocks, leaves, marbles, flowers) inside it. This demonstration shows how the color of crystal is affected when a flower is placed inside it.

MATERIALS LIST

- **Surface** *300-lb. (638gsm) rough watercolor paper*

- **Paints** *Antwerp Blue*
 Indian Yellow
 Payne's Gray
 Permanent Sap Green
 Winsor Red
 Yellow Ochre

- **Brushes** *Rounds: no. 1, no. 2, no. 3*

- **Other** *Bounty paper towels*

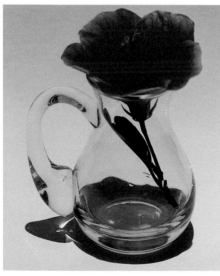

Reference Photo

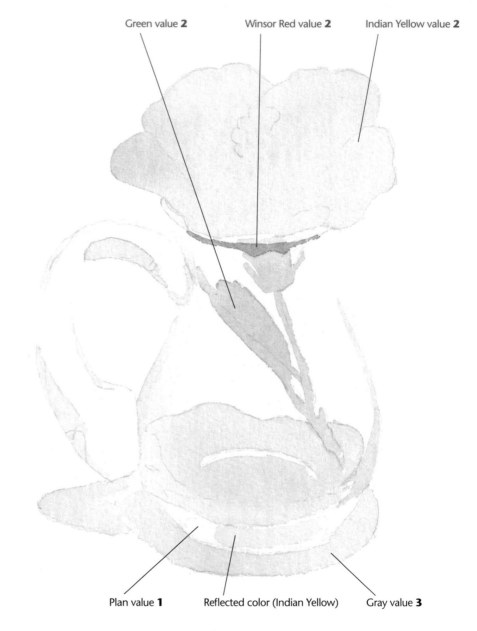

Green value **2** Winsor Red value **2** Indian Yellow value **2**

Plan value **1** Reflected color (Indian Yellow) Gray value **3**

1 **Plan Your Values and Begin Painting** | Mix Payne's Gray and Yellow Ochre with your no. 3 brush. This will have a smoky gray appearance and will represent the glass. Mix another glaze of Winsor Red, Permanent Sap Green, Yellow Ochre and Payne's Gray. This will become a brownish warmer color, representing the flower and its reflection.

Leave value **1** as the white of the paper at the bottom of the pitcher, and at the top under the rim. Use a no. 2 brush to paint a gray value **2** over the whole pitcher except the value **1** areas. Let dry.

Paint the flower and its reflection in the bottom of the pitcher with a value **2** Indian Yellow glaze with a no. 3 brush. Let dry. Paint a Winsor Red value **2** glaze at the top of the pitcher under the rim as reflected color with your no. 1 brush. Let dry. Paint the flower's stem and leaf, as well as the right side of the pitcher, a value **2** green, from a Permanent Sap Green–Payne's Gray mix.

Mix and paint a gray value **3** over the rim of the pitcher, the handle areas, the bottom and middle of the pitcher and the pitcher's shadow. Soften the edges of the pitcher to help it turn in space.

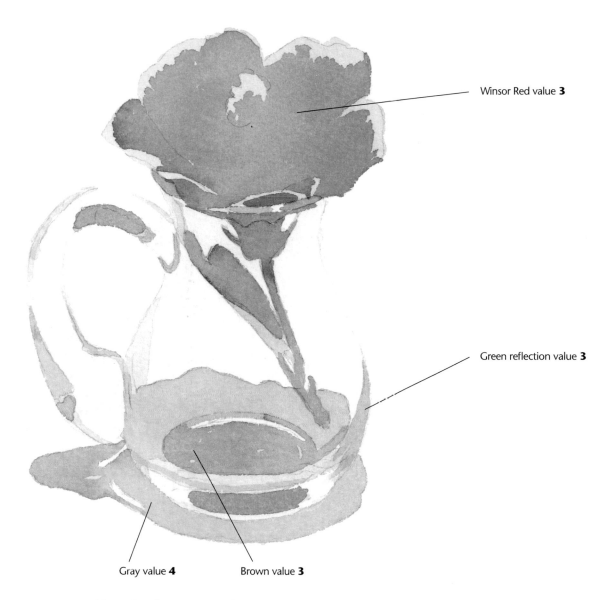

Winsor Red value **3**

Green reflection value **3**

Gray value **4** Brown value **3**

2 **Continue Building Values** | Paint a gray value **4** glaze over the handle areas and bottom of the pitcher and in the shadow. Fuse a brown value **3** glaze into the handle, rim, bottom and shadow of the pitcher with your no. 3 brush using a wet-in-wet technique to create reflected color from the flower. Let dry.

Mix a value **3** glaze of Winsor Red and paint the hibiscus, leaving the edges yellow. Use this same glaze and your no. 2 brush to paint the reflected color in the bottom of the pitcher. Let dry.

Mix a green value **3** and paint the leaf and stem, leaving some value **2** showing to help turn the leaf. Glaze some of this green as reflected color on the right bottom corner of the pitcher with your no. 1 brush. Let dry.

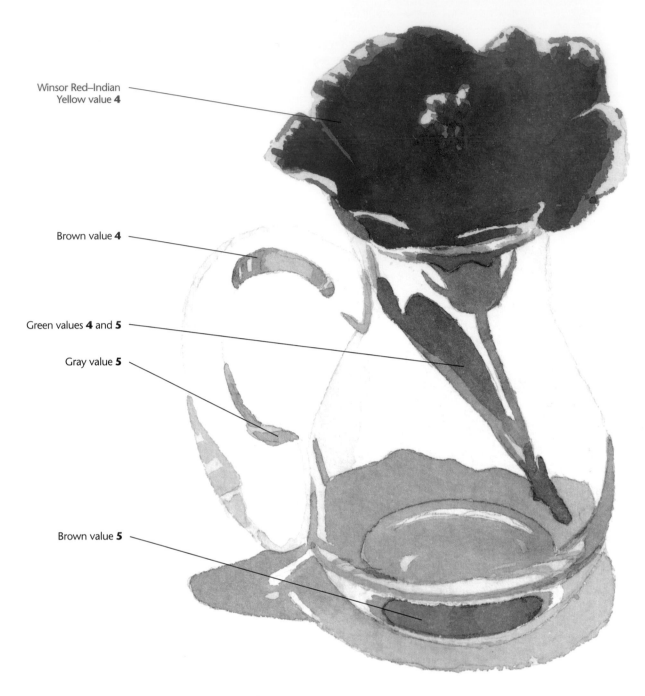

Winsor Red–Indian
Yellow value **4**

Brown value **4**

Green values **4** and **5**

Gray value **5**

Brown value **5**

3 **Go Even Darker** | Use your brown glaze from step 2 and your no. 1 brush to paint a few vertical bands in the reflected color at the bottom of the pitcher. Mix a brown value **5** and paint in the handle areas and bottom of the pitcher with your no. 2 brush. Let dry.

Mix a Winsor Red–Indian Yellow value **4** glaze and paint the hibiscus. Let other layers show in places. When dry, go back in with your no. 2 brush and a value **5** mix of Winsor Red–Indian Yellow–Permanent Sap Green–Payne's Gray (looks like Burnt Sienna) and paint the center of the flower and along some of the petal edges. Let dry.

Mix a gray value **5** and paint the pitcher in the center with your no. 2 brush, and along some handle areas, on the rim and in the shadow with your no. 1 brush. Let dry.

Paint a green value **4** over leaf and stem with your no. 1 brush, then go over that with a value **5** green mix.

Add some Antwerp Blue with your no. 1 brush near the reflected color at the bottom of the pitcher as "unexpected color" that helps give a vibrancy to the painting.

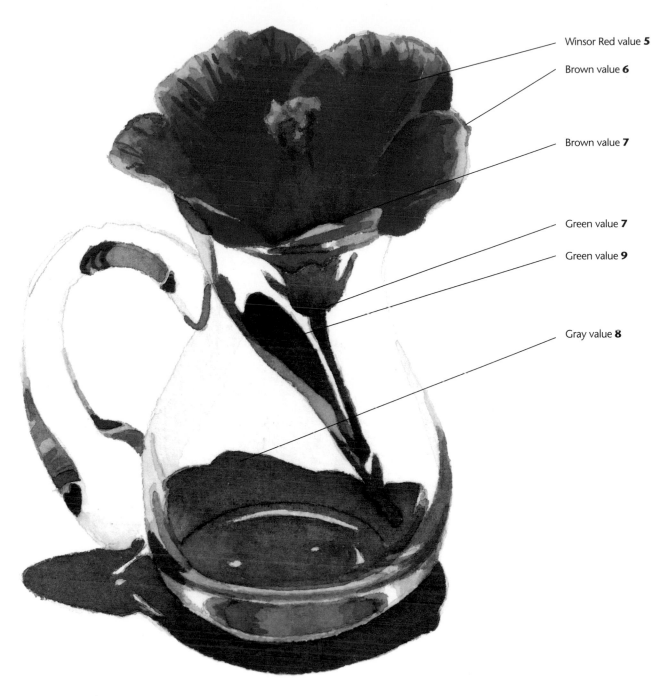

Winsor Red value **5**

Brown value **6**

Brown value **7**

Green value **7**

Green value **9**

Gray value **8**

4 **Add Darkest Darks** | Intensify the unexpected color with your no. 1 brush and a layer of blue, value **5**. Paint Winsor Red value **5** over the hibiscus, pulling the paint out to the edges to give a vein appearance. When dry, add brown value **6** to the edges and center of the flower with your no. 2 brush.

Add brown value **7** to the base of the flower to help it turn in space. Add this same glaze to the shadow and bottom of the pitcher.

Mix a green value **7** and paint the stem and leaf with your no. 1 brush. Make a darker value **8** green and paint reflected color on the right side of the pitcher. When dry, dampen the area that holds the flower on the stem and then add green value **9** with your no. 1 brush wet-in-wet to give variety to the stem. Let dry.

Mix a gray value **8** and paint some of the shadow and pitcher with your no. 0 brush, leaving darker values **9** and **10** grays to add sparkle in each end of the handle.

CREATE COLOR FROM BEHIND CRYSTAL

Place an object behind the crystal, and color reflects through the back of the glass.

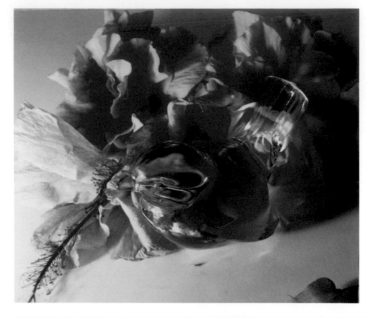

MATERIALS LIST

- **Surface** 300-lb. (638gsm) rough watercolor paper

- **Paints** Burnt Sienna
 Cadmium Orange
 Payne's Gray
 Permanent Magenta
 Permanent Rose
 Rose Doré
 Winsor Red
 Winsor Violet
 Yellow Ochre

- **Brushes** Rounds: no. 1, no. 2, no. 3, no. 4, no. 5

- **Other** Bounty paper towels

1 **Plan Your Values and Begin Painting** | Leave the whites alone as value **1**. Mix a value **2** Yellow Ochre–Rose Doré glaze, and paint the left flower and bird with your no. 3 brush. Let dry.

Add Winsor Red to the mix, and paint the middle flower and the bird with your no. 3 brush. Let each color on the bird dry before placing the color next to it to keep the edges hard.

Mix a value **2** Yellow Ochre–Permanent Rose–Permanent Magenta glaze and paint over the right flower and bud with your no. 3 brush. Let dry, then go back in and repeat some value **3** glazes as necessary.

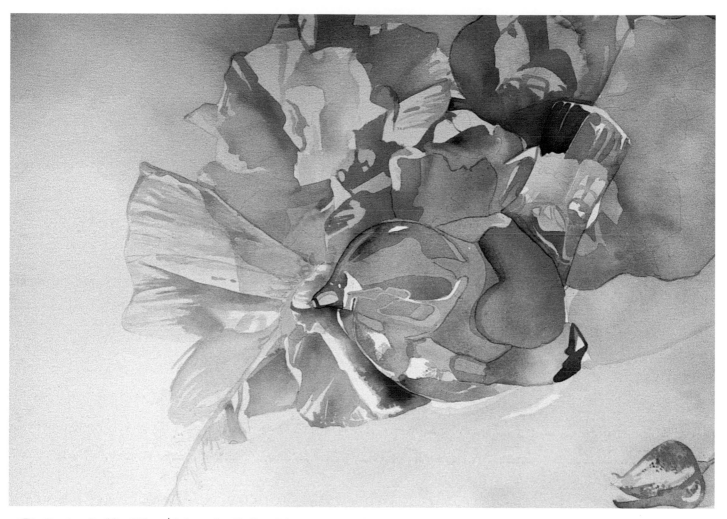

2 **Continue Building Values** | Mix a value **3** Yellow Ochre–Rose Doré glaze, and paint the left flower petals and the bird with your no. 2 brush. Add Winsor Red and Cadmium Orange to the glaze, and paint the middle flower's petals and the bird. The orange warms the middle flower and helps separate the two flowers from one another.

Mix a value **3** Permanent Rose–Permanent Magenta for the right flower, bird and flower bud.

Begin painting the bands on the bird with your no. I brush and a value **3** Burnt Sienna–Payne's Gray mix.

Begin the background with your no. 4 or no. 5 brush and a value **2** Yellow Ochre–Rose Doré–Burnt Sienna glaze, repeating with values **3** and **4** of those colors.

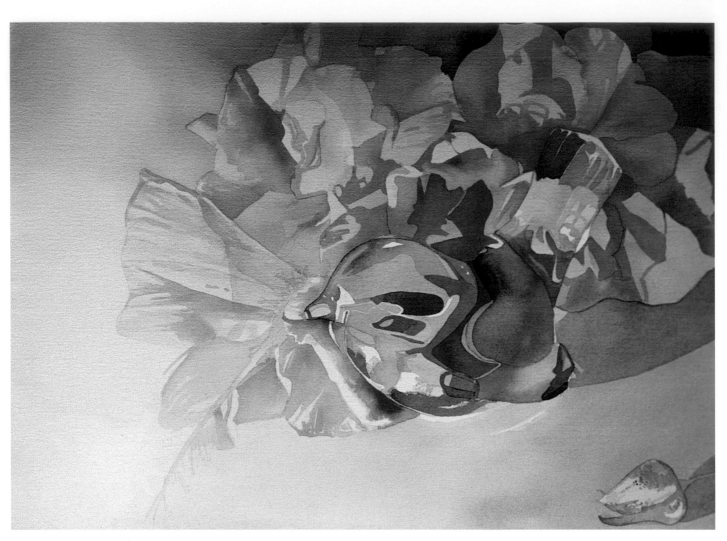

3 **Go Even Darker** | Paint a value **4** Yellow Ochre–Rose Doré–Cadmium Orange–Winsor Red glaze on the middle flower and the bird with a no. 2 brush. Let dry. Use your no. 2 brush to paint a value **4** Permanent Rose–Permanent Magenta–Winsor Violet glaze on the right flower, the bird and the flower bud. Let dry.

Paint the bird with Winsor Red and your no. 1 brush to make it stand out more. Add Burnt Sienna and Payne's Gray again on the bird with your no. 1 brush, and on the background with your no. 4 brush at the top and your no. 5 brush on the right side.

Begin the foreground with a value **3** Yellow Ochre–Burnt Sienna glaze and your no. 3 brush.

When all is dry, add areas of value **5** and value **6** paint mixes throughout as needed.

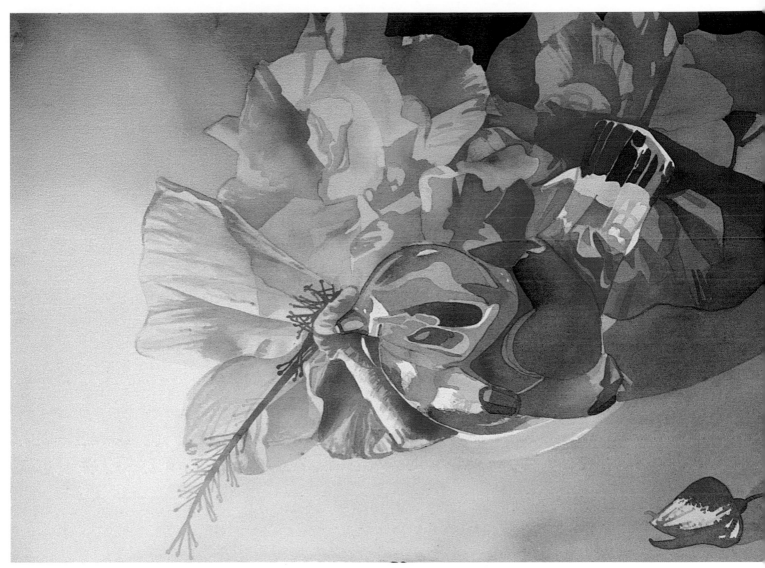

4 **Add Darkest Darks** | Use a no. 1 brush to paint the left flower's center with a value 6 Winsor Red. Let dry. Use your no. 3 brush to paint a mix of Cadmium Orange, Yellow Ochre and Permanent Rose as values 7 and 8 on the middle flower and the bird. When dry, use your no. 2 brush to paint numbers 7 and 8 value mixes of Permanent Magenta, Winsor Violet and Permanent Rose for the shadow area on the right flower. Then when dry, use your no. 2 brush to paint the bird with numbers 7, 8 and 9 value mixes of Burnt Sienna and Payne's Gray. Add a value 10 Payne's Gray on the tail section of the bird with your no. 1 brush.

Finish the background with Payne's Gray–Burnt Sienna mixes, values 8 and 9, and your no. 4 and no. 5 brushes. Finish the foreground with a value 5 Burnt Sienna–Yellow Ochre–Winsor Red mix and your no. 3 and no. 4 brushes.

Spanish Fiesta
30" x 39" (76cm x 99cm)
Collection of the artist

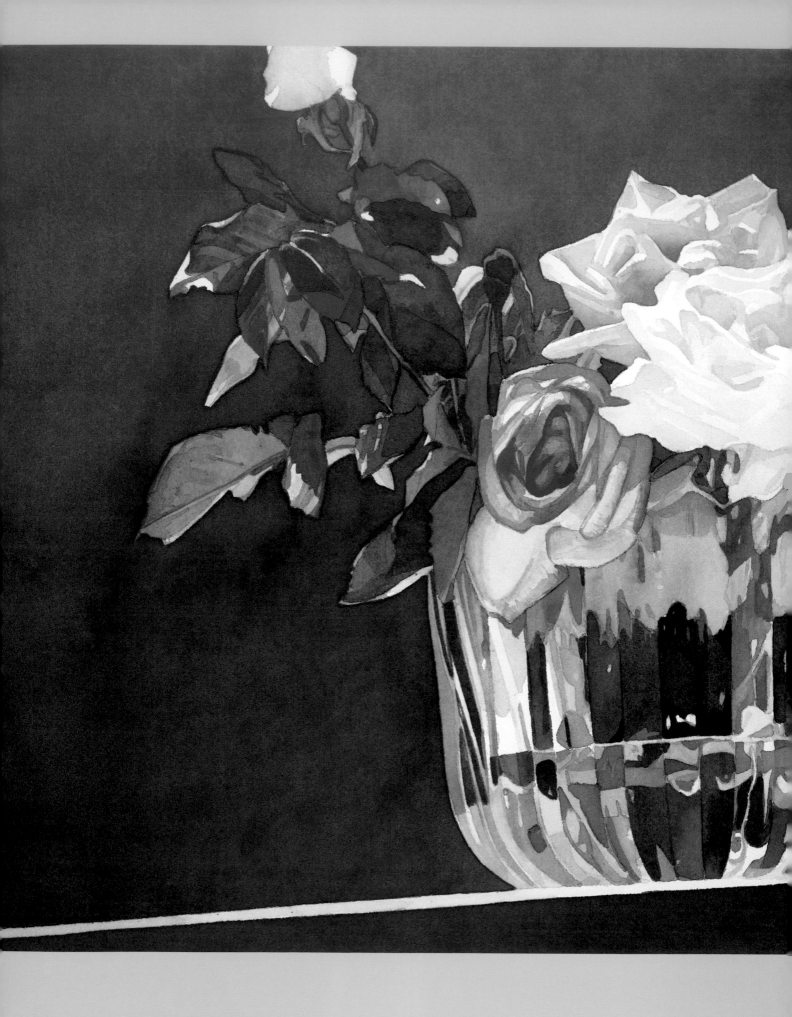

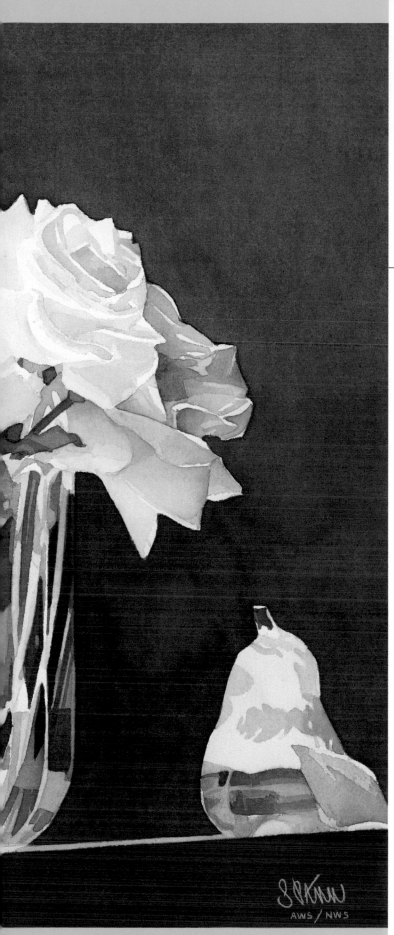

Addition
of Elements

The addition of elements to your crystal and flower painting is like adorning your work with selections from a fabulous wardrobe. The extra elements are the clothing of a composition. They add variety and spice to your bouquet and crystal. The additional elements can enhance the brilliance of glass and encourage its love affair with the arrangement of enchanting flowers. The additional elements you add to your crystal and flowers will help create a style and body of work that becomes uniquely yours.

Pearcision in Glass
Puzzle of Pears Series
30" x 40" (76cm x 102cm)
Collection of Robin and James Stojak

SMOKY BACKGROUNDS

A smoky, swirling texture is created by adding paint glazes to a wet paper surface. The soft, smoky background is contrasted with the hard lines of the crystal.

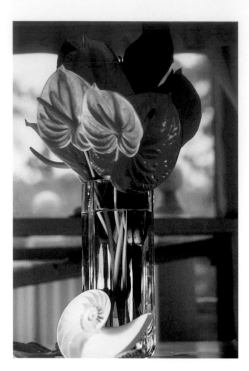

MATERIALS LIST

- *Surface* 300-lb. (638gsm) rough watercolor paper

- *Paints* Antwerp Blue
 Cadmium Lemon
 Payne's Gray
 Permanent Sap Green
 Ultramarine Turquoise

- *Brushes* Rounds: no. 2, no. 3, no. 4, no. 5

- *Other* Bounty paper towels

Reference Photo | Using a smoky background with this still life will add drama to the crystal vase and will help the flower and leaves pop from the painting. The "smoke" will surround the vase with dark values and allow the leaves and flowers to be dark objects against a white background.

THE ROLE OF BACKGROUNDS

The crystal and flowers are the stars of the painting. Backgrounds are the supportive cast members, yet they add their own statements.

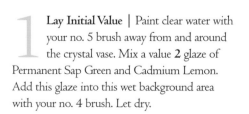

1 Lay Initial Value | Paint clear water with your no. 5 brush away from and around the crystal vase. Mix a value **2** glaze of Permanent Sap Green and Cadmium Lemon. Add this glaze into this wet background area with your no. 4 brush. Let dry.

2 Build Color | Redampen the smoke area (middle of the background) with clean water and your no. 5 brush. Use your no. 4 brush to mix and apply a value **3** glaze of your background color (add more Permanent Sap Green) over the entire background area. You can use a small piece of damp paper towel to soften smoky areas by dabbing at the paint. Let dry.

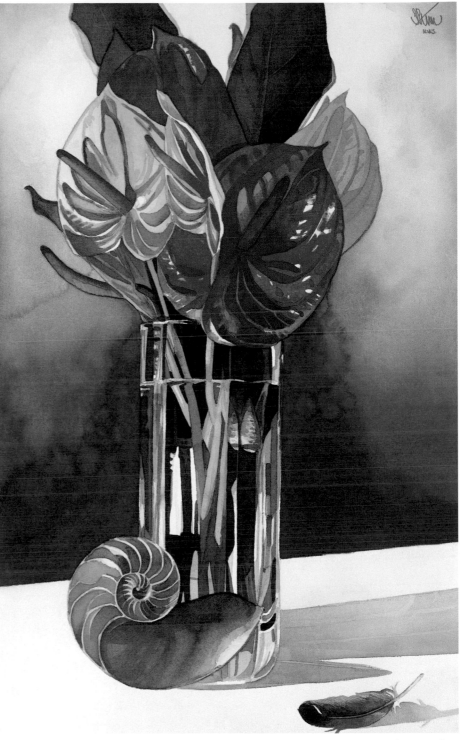

3 **Add a Cool Tone** | Continue mixing glazes with your no. 5 brush to reach the desired values. Cool the mixture with a little Ultramarine Turquoise and your no. 4 brush. Let each glaze dry before adding new ones. If they are not dry, they will mush together.

4 **Add Final Glazes** | Continue to add clear water in the center areas of the background with your no. 5 brush. Add a new glaze mixture of Antwerp Blue and Payne's Gray to the background. Paint wet-in-dry up to the crystal with your no. 2 brush. Paint wet-in-wet in the smoky areas with your no. 3 brush.

Land, Sea and Air
30" x 40" (/6cm x 102cm)
Collection of Liza and Ken Kobic

Rainbow Backgrounds

A variation of the smoke background is a
background called rainbow. It is painted
exactly the same as "smoke," just in the
direction of a rainbow. A change in tempera-
ture can occur going from warm to cool.
The rainbow background works like book-
ends and traps white in the middle.

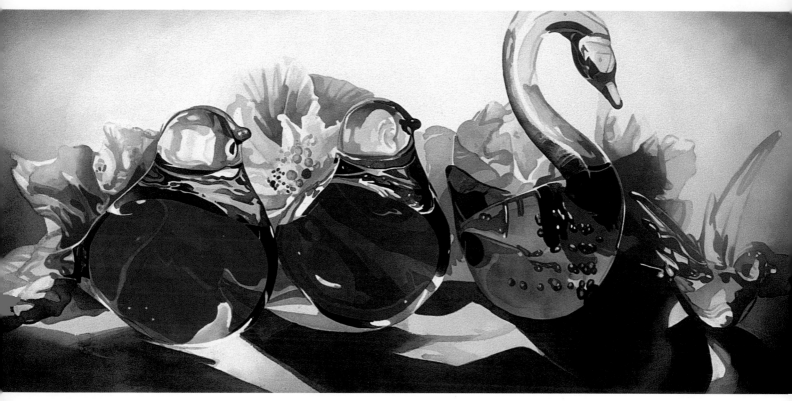

My Glass Menagerie
30" x 60" (76cm x 152cm)
Collection of Dr. and Mrs. Mark Jank

Graded Backgrounds

The graded background painting technique goes from light to dark values of the same color, or analogous family. It is done in steps of glazes with only a few passes of clear water painted into heavier pigment. My gradations don't have the true gradual value shifts applied by most artists. Mine tend to have a textured feeling. A graded background gives a solid feel and interesting subtle textures.

Reference Photo | A graded background adds interest to the background without allowing it to take over the foreground shapes. You could add more of the beautiful turquoise and aqua colors to the painting to enhance the colors in this still-life setup.

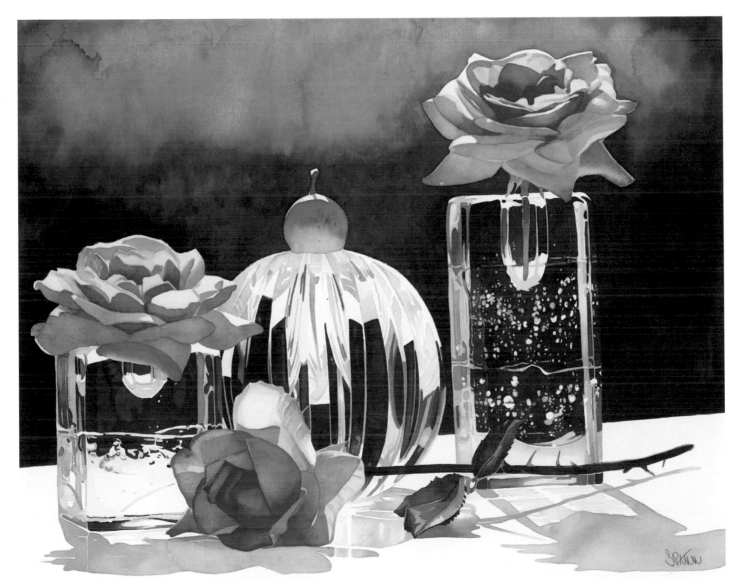

Three Musketeers
35" x 45" (89cm x 114cm)
Collection of Anna and Jay Levit

Whispery Backgrounds

This background is so light in value that it is called a whisper. A whisper background allows a lot of white to remain in the painting but softened into values **2** and **3** for variety.

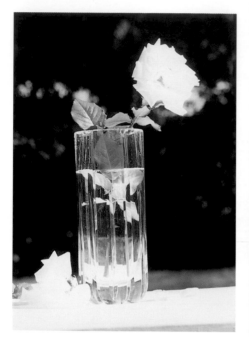

Reference Photo

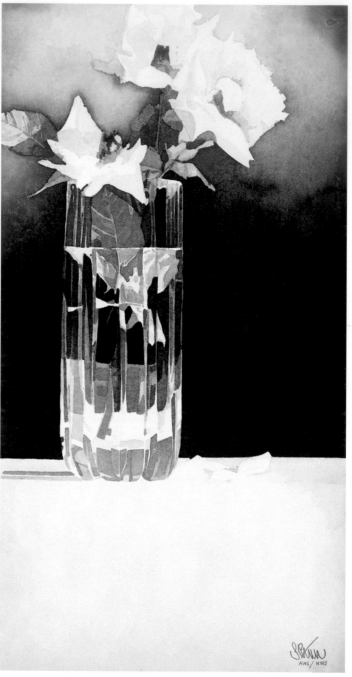

Time Stands Still
42" x 26" (107cm x 66cm)
Collection of Edna Bick and John Helson

Painting a Whisper | Paint clear water in the whole white area. With your brush, quickly paint just the edges of the paper with value **2** of your color. If the paint goes too far into the white area, dab with a piece of damp paper towel. Let dry thoroughly. Repeat with value **3** of the same color or use a different color, same color family. If the paint looks too light to make a difference, darken the glaze a little, but don't go too dark. You don't want this technique to shout.

Solid Backgrounds

Of all the backgrounds, a solid one takes the most time and pigment to complete. It can have a velvety texture and makes crystal really dazzle.

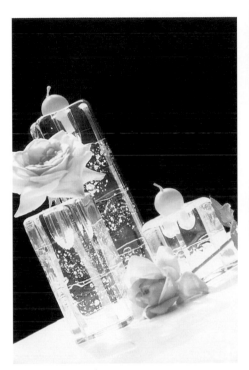

Reference Photo | A Permanent Sap Green, Antwerp Blue and Payne's Gray mix in the background would pop out the crystal and create a dramatic backdrop.

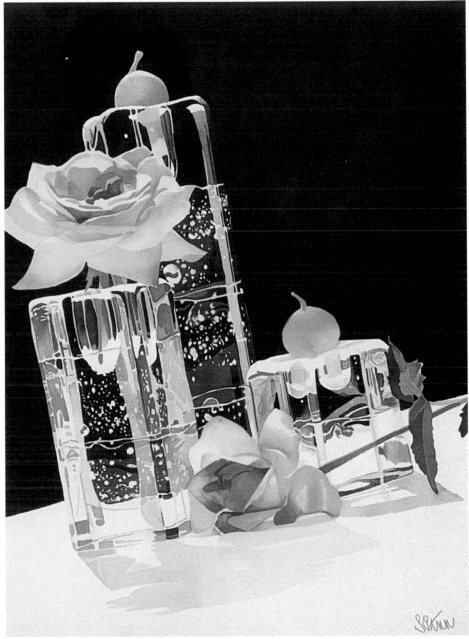

Painting a Solid Background | Build a solid background with layers of paint, drying thoroughly between each glaze. Pull your brush over the paper surface by gathering the pool of paint and pulling it over the mountains and valleys of the paper. Do not scumble. This will dislodge any previous paint layers and cause the color to look muddy. Think of the wet surface as a river. You do not want to go too far beneath it. I call this action "drop and flow."

Moonlight Magic
40" x 32" (102cm x 81cm)
Private collection

Using Formed Shadows

A formed shadow is soft edged. It is caused by light hitting on the object itself. It is painted with wet-in-wet glazes.

Formed Shadows on Flowers | Cover the whole petal with clean water. Drop in paint on the edges of the petals and let the color fuse toward the middle. This makes the petal appear to turn. Let dry. To make the edges darker, go back in with clear water and repeat. Let the previous glaze show through across the middle.

Do one petal at a time. This keeps the edges of each petal clean and separate from the others.

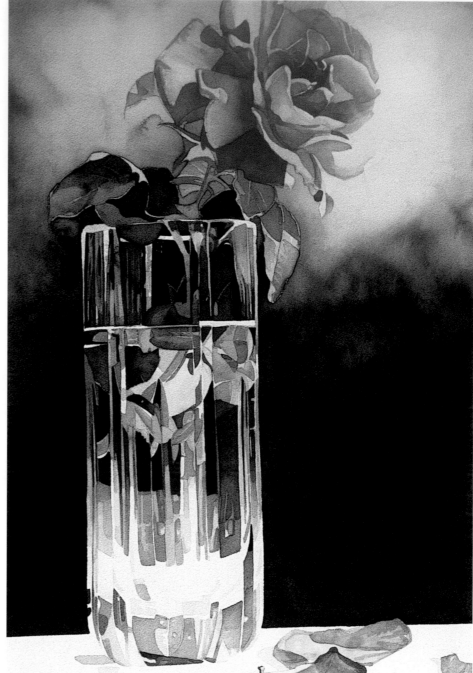

The formed shadows of the leaves and petals were done with various fusions of glazes.

From a Peanut to a Princess
40" x 32" (102cm x 81cm)
Collection of Beth and Bob Dobbs

Using Cast Shadows

A cast shadow is hard edged. It is caused by light hitting an object and casting its shadow on another object.

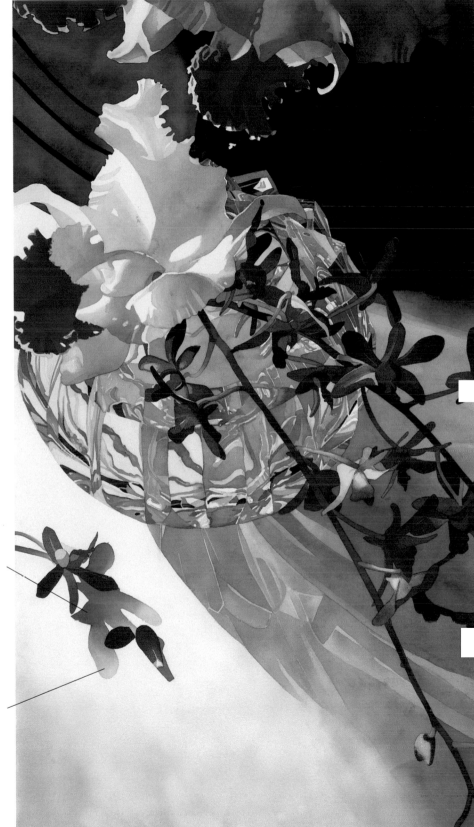

A shadow is darker at the base of the object.

A shadow becomes lighter as it travels away from the object.

Stolen Moments
60" x 36" (152cm x 91cm)
Collection of Patricia and Jeffrey Aresty

Ambient Color

Ambient color is color thrown from one object onto the surface of another. For example, when you wear a pink dress or shirt, you may notice ambient color as a pink flush on your jawline or in your cheekbones. It is less intense and bright than local color (the color of the object itself).

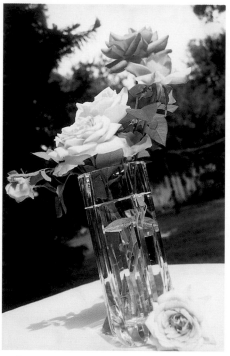

Reference Photo

Ambient Color in Shadows | The yellow rose casts its ambient color on the table surface as a light yellow shadow. The crystal vase has an orange hibiscus behind it. This flower throws its ambient color as a shadow of an orange and green glaze. This is made by adding clear water to the shadow area and dropping in the local color of the object.

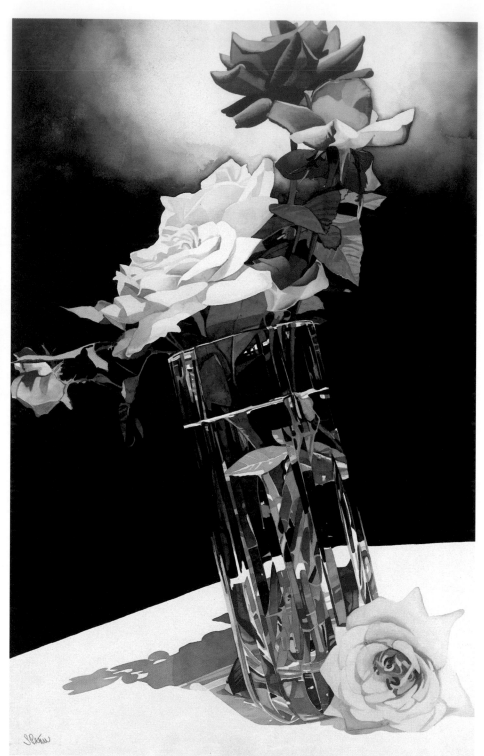

Bewitched by Saturday's Child
60" x 40" (152cm x 102cm)
Collection of Linda and John Baird

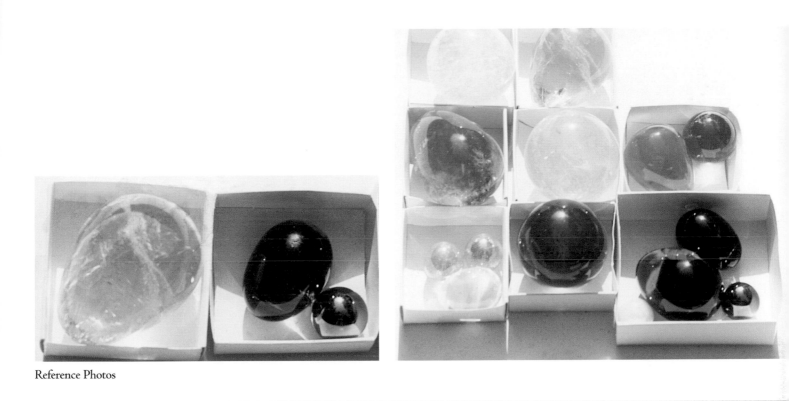

Reference Photos

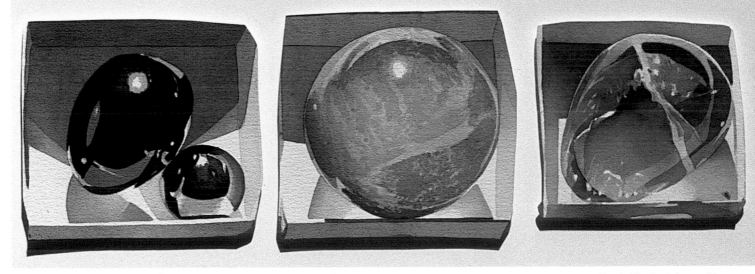

Ambient Color in Reflections | Each crystal ball throws its color in the shadows and background.

Crystal in Containers, #3
Crystal and Containers Series
Each container is 7" x 7" (18cm x 18cm)
Collection of the artist

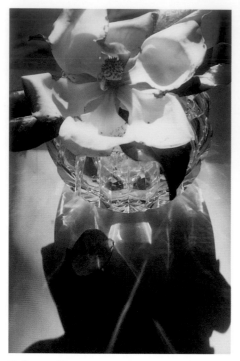

Reference Photo

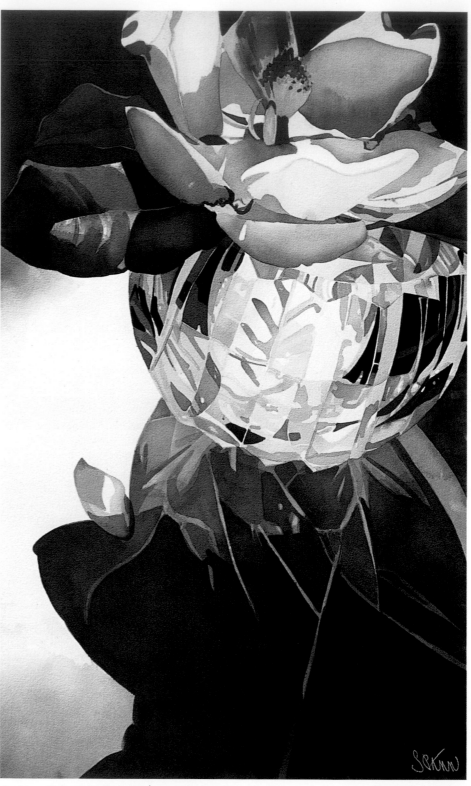

Ambient Color in Refractions | The cream color of the magnolia and the purple background and foreground are seen abstracted in the facets of the crystal.

Magnolia by Sunset
40" x 30" (102cm x 76cm)
Collection of Christina Kobe

Elements of Elegance

Flowers and crystal can be enhanced further
by adding symbols of elegance, such as deli-
cate laces, rich fabrics and stunning jewelry.
At times, adding other objects will help to
make a stronger composition.

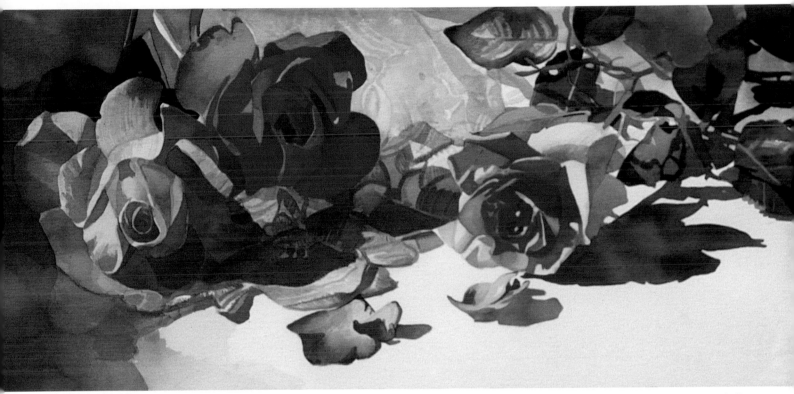

Lace | Lace is a beautiful texture filled with turns and twists of positive
and negative shapes. It creates an elegant atmosphere and is a great place for
shadows to fall upon. The lace gives a place for the roses to recline. It
repeats the flower's shape, adding a rhythm to the composition.

Manhattan Melodies
30" x 48" (76cm x 122cm)
Collection of Dale and Andy Tessler

Fabrics | Not only can fabrics add rich textures and exciting color, they can be placed behind crystal and bouquets to give color when needed. The silk brocade and the patterned lace add to the grace of the gladiola. Shadows repeat the shapes of the flower's stalk.

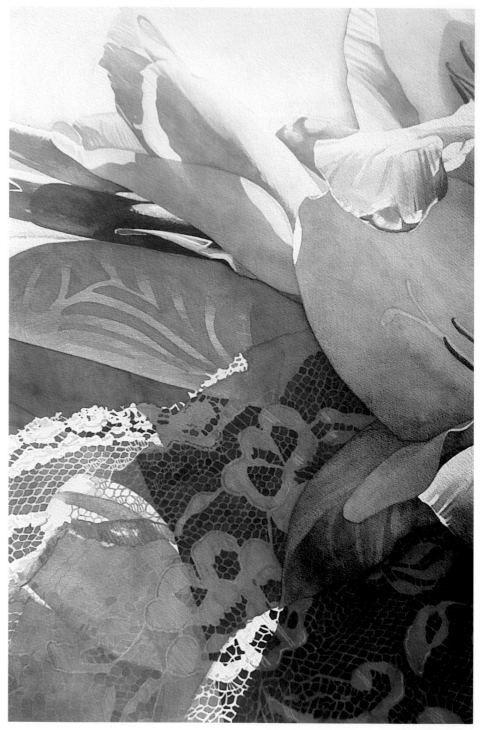

Alice Blue Gown
40" x 30" (102cm x 76cm)
Collection of Joy and Marvin Silverman

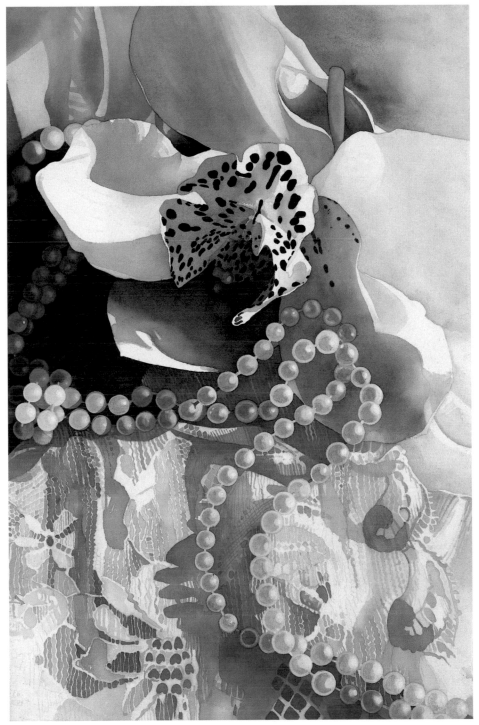

Jewelry | Pearls on lace add a romantic interest and story to the orchid. The shadow of the pearls is the ambient color of the green brocade in the background. In this painting the pearls were done last with Chinese White, Permanent Sap Green and Yellow Ochre. Chinese White is an opaque watercolor and will "spider," or bleed, into surrounding colors if they are not dry. I wanted a pearlized look, so I did the whole painting first and then did the pearls.

First Prom
40" x 30" (102cm x 76cm)
Collection of West Palm Beach's Sunfest Art Festival

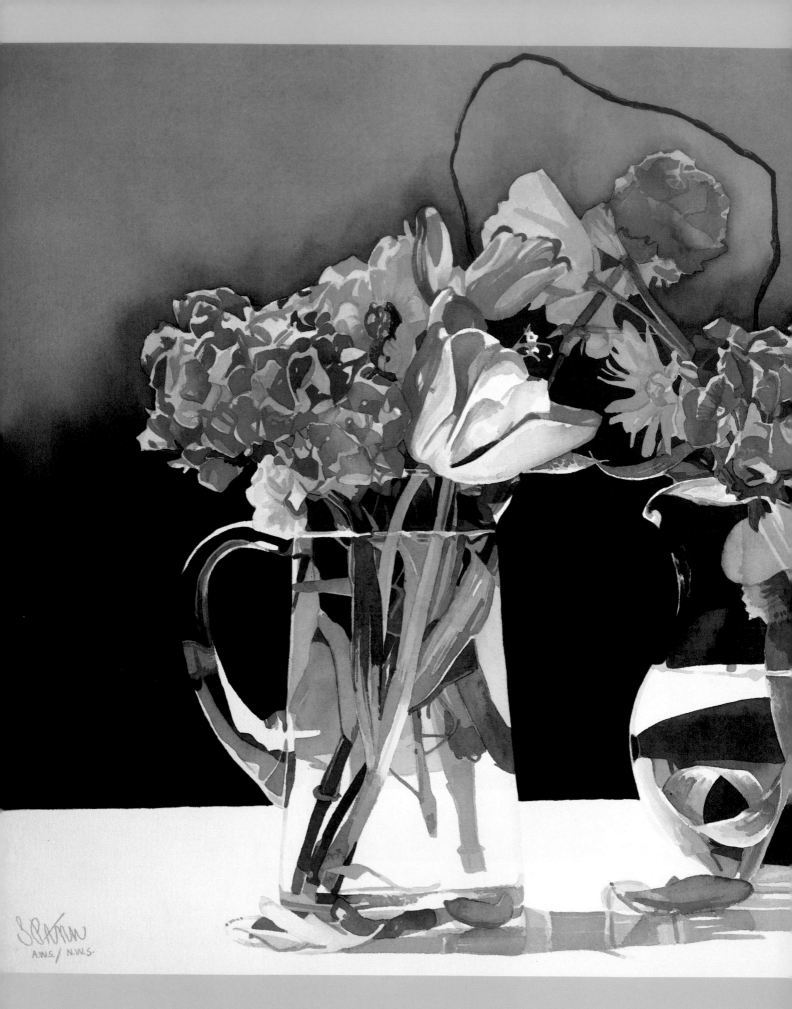

Making a Painting

After getting a feel of photography, value, composition and color, it is time to begin painting. This chapter uses your skills from the previous chapters to place brush to paper and create your own crystal and flower paintings, complete with backgrounds, as well as shadows and other elements that will make your painting more interesting.

Before you begin, look at your photo references or set up a still life and spend time seeing and visualizing how light passes through flower petals and leaves. Really look at crystal shapes and color. This will help in deciding how to better compose or change objects a bit to make a stronger painting.

Shall We Dance
45" x 60" (114cm x 152cm)
Collection of Janet and John Ricketts

Painting Crystal and Flowers

The demonstration in this chapter covers the full value scale in the painting of two crystal birds and three flowers. This glaze method of painting is time-consuming, so patience is a must! Let each layer, or "pass," of color dry completely before painting another pass of values.

Materials List

⊷ **Surface** 300-lb. (638gsm) rough watercolor paper

⊷ **Paints** Burnt Sienna
 Cadmium Orange
 Cadmium Yellow Deep
 Gold Ochre
 Indian Yellow
 Payne's Gray
 Permanent Magenta
 Permanent Rose
 Permanent Sap Green
 Quinacridone Burnt Sienna
 Quinacridone Gold
 Quinacridone Red
 Quinacridone Rose
 Quinacridone Violet
 Rose Doré
 Ultramarine Turquoise
 Winsor Red
 Winsor Yellow
 Yellow Ochre

⊷ **Brushes** Rounds: no. 1, no. 2, no. 3, no. 4, no. 5

⊷ **Other** Bounty paper towels
 Pencil

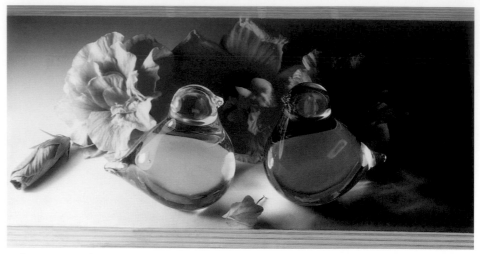

Reference Photo | You may need to tape off portions of your photo to crop in and create an interesting composition.

Value Sketch | Work out your values ahead of time with a thumbnail value sketch so you can figure out the value combinations that will really pop the subject from the background.

1 | PLAN YOUR VALUES AND BEGIN PAINTING

Plan the number **1** values and leave these areas alone. Mix and paint value **2** glazes on your palette, moving across the painting from left to right, letting each object dry completely before painting the object next to it.

1 **Paint the Left Flowers and Bird** | Paint the left flower bud with a Yellow Ochre–Winsor Yellow–Rose Doré mix using a no. 4 brush. Use a Yellow Ochre–Rose Doré glaze on the larger left hibiscus, adding a glaze of Yellow Ochre toward the top of the bloom. This will give these flowers a warm glow.

Mix a Yellow Ochre–Burnt Sienna–Rose Doré glaze, and paint the left crystal bird with your no. 3 brush.

Glaze the foreground with a pale Yellow Ochre glaze using your no. 4 brush. Let all glazes dry completely.

2 **Paint the Middle Flower** | Mix a Cadmium Yellow Deep–Rosé Dore–Indian Yellow glaze, and paint the middle flower with your no. 4 brush. Let dry.

3 **Paint the Right Side of the Painting** | Mix an Indian Yellow–Yellow Ochre glaze and with your no. 3 brush, paint the right crystal bird. When this glaze dries, add some Payne's Gray to the mix and paint in the bird's head and tail area with your no. 1 brush. This will begin the dark bands that make the crystal look like glass.

Paint the right flower using your no. 3 brush with a Burnt Sienna–Yellow Ochre–Permanent Rose–Permanent Magenta glaze. Let dry.

2 | CONTINUE BUILDING VALUES

Mix and paint number **3** then number **4** values, letting each object dry before painting the one next to it. Again, move from the left to the right as you paint.

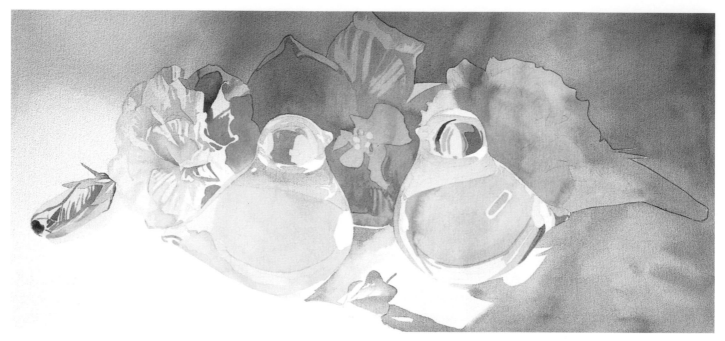

1 Paint the Background | Use your no. 4 brush to paint the left background with clear water, then drop in a Yellow Ochre glaze. Let the water and paint fuse to capture a smoky appearance. Let this glaze dry. Then mix a Yellow Ochre–Payne's Gray glaze, and continue painting with your no. 5 brush from the middle background to the right side of the painting. Mix a Burnt Sienna glaze into the Yellow Ochre–Payne's Gray background glaze and paint the background on the right side with your no. 5 brush, helping this side become darker and more olive in appearance.

2 Paint the Left Flowers | Make the green stem warm with reflected color from the surrounding flowers by painting it wet-in-wet with a Cadmium Orange–Payne's Gray–Permanent Sap Green mix and your no. 3 brush.

Add Cadmium Orange on the tips of the flower bud with your no. 1 brush. Continue on the bud, painting in the veins with your no. 2 brush and Winsor Red.

Work on the bud's shadow by mixing Rose Doré and Cadmium Orange into the Winsor Red to give the shadow ambient color.

Paint the larger bloom wet-in-wet using your no. 2 or no. 3 brush, beginning cooler areas with a Rose Doré–Winsor Red–Permanent Rose mix.

3 **Paint the Left Bird and Middle Flower** | Paint the left crystal bird wet-in-wet using your no. 2 brush with a glaze made from Cadmium Orange and Burnt Sienna plus the mixture on your palette from the left flowers and shadow.

Paint the foreground with this same mixture, adding some Yellow Ochre and Cadmium Yellow Deep.

Paint the middle flower with a Burnt Sienna–Indian Yellow–Cadmium Yellow Deep–Cadmium Orange mix. For cooler areas on the flower, use your no. 3 brush and mix a Quinacridone Burnt Sienna–Winsor Red glaze.

When these glazes dry, mix an Indian Yellow–Cadmium Orange–Cadmium Yellow Deep glaze for the center of the flower, and paint with your no. 2 brush.

4 **Paint the Right Side of the Painting** | Paint the right crystal bird using your no. 2 brush with a Cadmium Orange–Burnt Sienna glaze. When this dries, continue painting the bird with a Burnt Sienna–Yellow Ochre–Payne's Gray glaze on its head.

With your no. 3 brush, paint the right flower with a Quinacridone Burnt Sienna glaze, then mix a Quinacridone Rose–Quinacridone Violet–Burnt Sienna glaze and paint the bottom of the flower.

Add some of this darker glaze to the head and tail of the right bird as reflected color. Also go back in with this color on the bottom of the left bird and the left flower shadow using your no. 1 brush.

Create a deeper value toward the center of the right flower using your no. 3 brush with a glaze mixed from Rose Doré, Payne's Gray, Burnt Sienna, Quinacridone Burnt Sienna and Quinacridone Rose. Let all glazes dry completely.

3 | Go Even Darker

Mix and paint values **5**, **6** and **7**, again letting each object dry before painting the one next to it as you move from left to right.

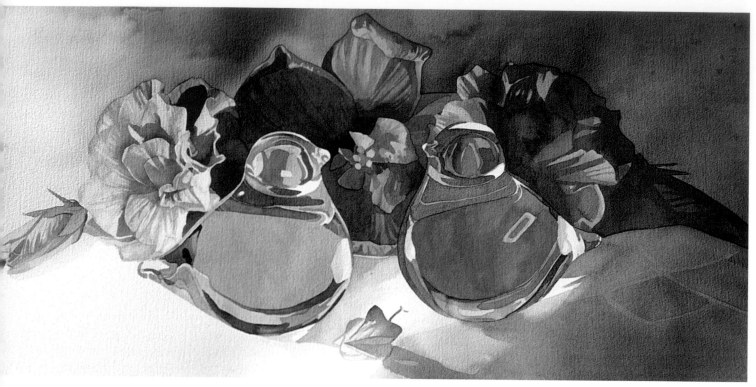

1 **Paint the Background** | Use your no. 5 brush to add clear water to the left side of the background, pulling it over to the right side of the painting. Mix a glaze from Payne's Gray, Yellow Ochre and a small dollop of Burnt Sienna, and let it fuse in with the water on the right side of the background. Let dry.

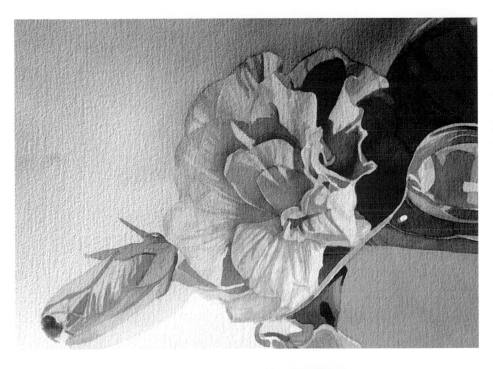

2 **Paint the Left Flowers** | Use your no. 2 brush to paint the large flower bloom on the left with a Cadmium Yellow Deep–Rose Doré glaze, going over all of the bloom except the highlights. Let dry.

Deepen the inside folds with a Winsor Red–Rose Doré glaze, topping the edges of the petals with a Gold Ochre–Rose Doré–Burnt Sienna–Cadmium Orange glaze and your no. 1 brush.

Add some Winsor Red to the inside of the flower bud and under the greenery of the stem. Add a Permanent Sap Green–Payne's Gray mix to the stem to add dimension. Add a Burnt Sienna–Winsor Red–Rosé Dore glaze to the shadow.

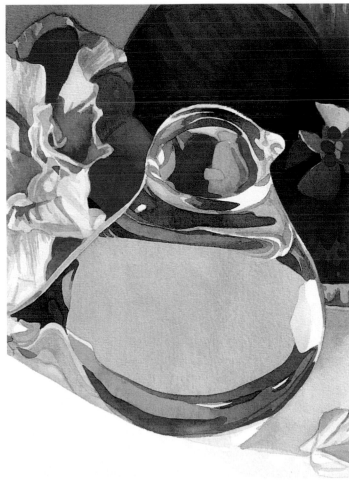

3 **Paint the Left Bird and Middle Flower** | Use the Burnt Sienna–Winsor Red glaze from the previous step to glaze the left crystal bird using your no. 3 brush.

Use your no. 1 brush to paint a Cadmium Yellow Deep–Yellow Ochre–Burnt Sienna–Rose Doré mix on the bottom curves of the bird and on the top of the bird's head. Paint a glaze of Payne's Gray on the bands of color in the bird's head to darken them.

Paint the middle flower using your no. 2 brush with a Quinacridone Gold–Burnt Sienna–Quinacridone Red–Payne's Gray–Yellow Ochre–Cadmium Orange mix. Paint the center wet-in-wet with your no. 1 brush, dropping in Winsor Red in the center as ambient color reflected from the hibiscus on the left.

To add light behind the flower petals, make the petal more gold by adding a glaze of Indian Yellow and Rose Doré. Add veins to the petals with a Burnt Sienna–Payne's Gray mix and your no. 1 brush, going wet-in-dry.

When dry, glaze the center of the flower with an Indian Yellow–Cadmium Orange–Rose Doré mix. When dry, add a glaze of Payne's Gray behind the center stamens.

4 **Paint the Right Bird** | Mix Quinacridone Magenta, Yellow Ochre, Quinacridone Burnt Sienna, Quinacridone Violet and Payne's Gray, and paint the right bird with your no. 3 brush.

When dry, use your no. 1 brush to paint the colored bands of the bird with a Rose Doré–Indian Yellow mix, adding in whatever is already mixed on your palette. Let each band dry.

For the bird's dark bands, glaze on Payne's Gray with your no. 1 brush, keeping edges hard. When this dries, add Ultramarine Turquoise to the top of the head and tip of the beak as a complementary and unexpected color.

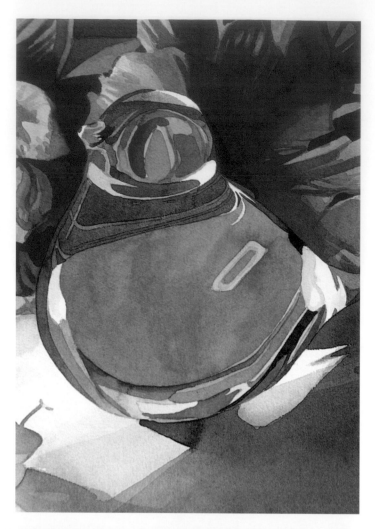

5 **Paint the Right Flower** | Paint the shadow areas of the right flower with a mixture of Rose Doré, Burnt Sienna, Quinacridone Violet, Payne's Gray, Quinacridone Rose and Permanent Magenta with your no. 3 brush. Use this same glaze to paint in the veins of the petals with your no. 1 brush.

4 | ADD DARKEST DARKS

Mix and paint your **8**, **9** and **10** values. Continue moving from the left to the right, letting each object dry before painting the one next to it.

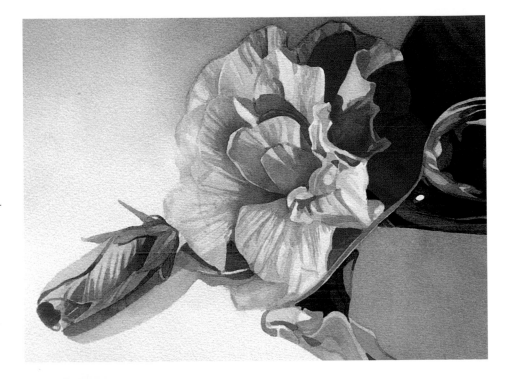

1 **Paint the Flowers on the Left Side** | Use your no. 2 brush to paint over the entire flower bud and leaf with a Cadmium Yellow Deep glaze to create the illusion that this flower is in bright light.

Deepen the folds of the larger bloom with a Permanent Rose–Rose Doré–Winsor Red mix, helping the hibiscus appear to turn from the inside to the outside.

Paint the edges of the petals with your no. 2 brush, using a glaze made from Gold Ochre, Rose Doré and Burnt Sienna.

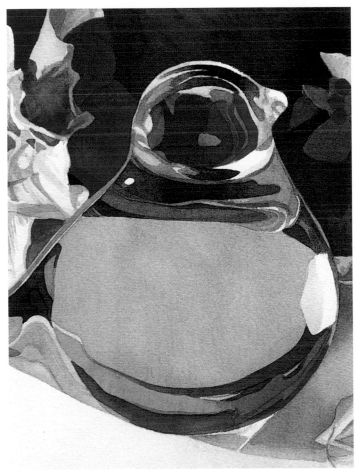

2 **Paint the Left Bird** | Use your no. 1 brush and the glaze from the left flower (previous step) to paint the lighter bands on the bird. Paint the dark bands on the left bird with a mix of Payne's Gray and Burnt Sienna.

3 **Paint the Middle Flower** | Paint the middle flower using your no. 3 brush with a mix of Payne's Gray, Quinacridone Burnt Sienna, Winsor Red, Gold Ochre and Cadmium Orange.

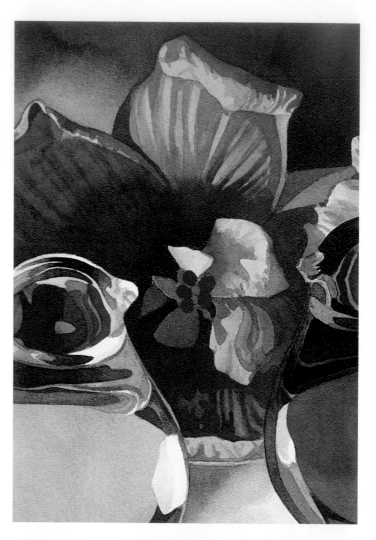

4 **Paint the Right Bird** | Paint the bands on the right bird with a mixture of Payne's Gray and Burnt Sienna using your no. 1 brush. Make the reds on the bird darker with a Permanent Magenta–Winsor Red glaze to help the bird appear to be in shadow.

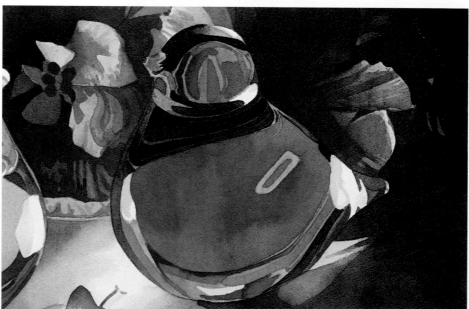

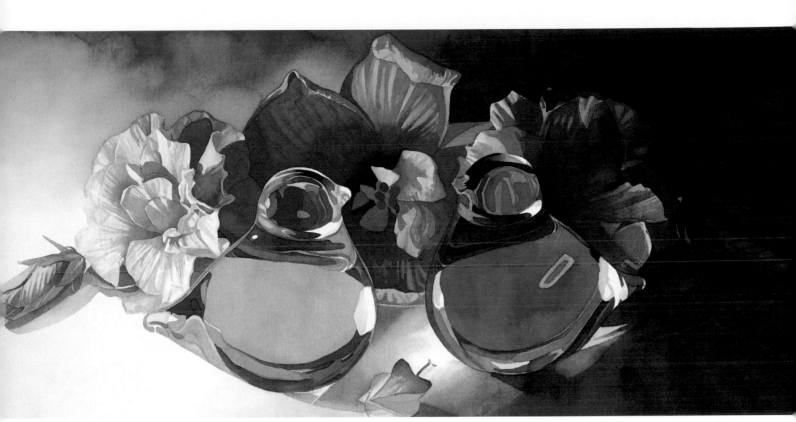

5 **Paint the Right Flower and the Background** | Paint the right flower with a Payne's Gray–Permanent Magenta–Permanent Rose–Burnt Sienna glaze to put this flower in shadow as well.

Use your no. 5 brush to paint clear water over the middle of the background. Mix a Payne's Gray–Yellow Ochre glaze, and drop it into this wet area, going from the right middle to the far right side of the background.

Let all dry and you're finished!

Two-Steppin' Twins
20" x 40" (51cm x 102cm)
Collection of Carol and Edward Lecuyer

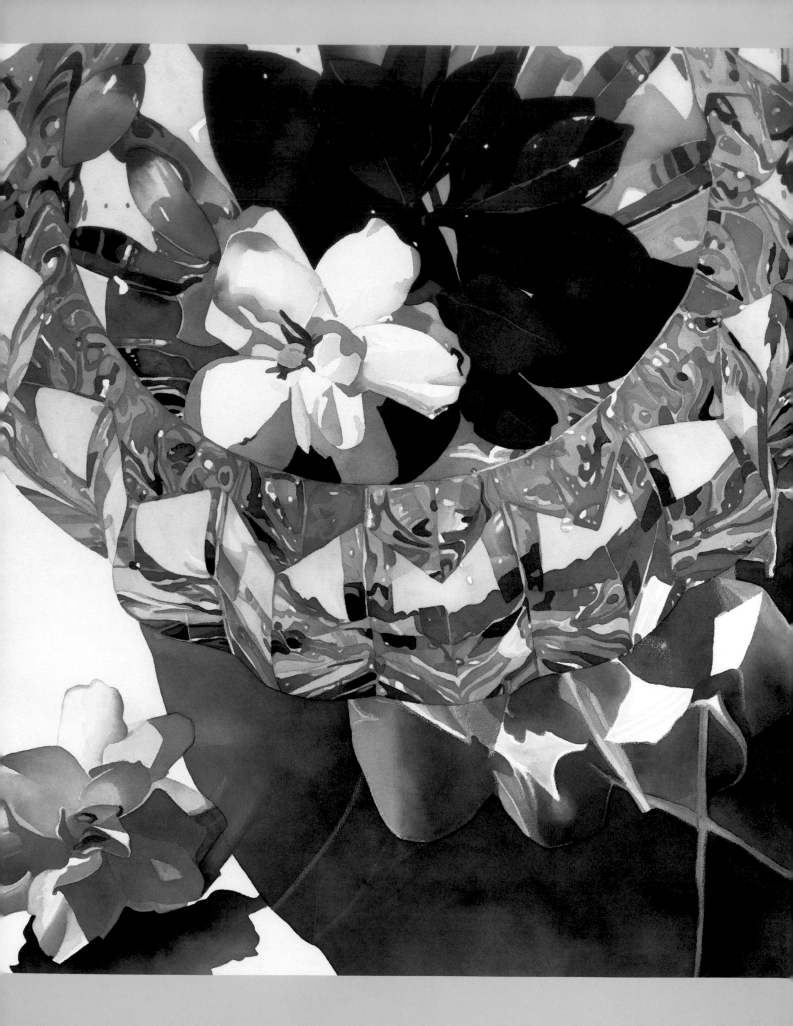

Finding Your Focus

Whenever you start a watercolor, think about why you are drawn to this particular piece of work. What is your focus? Why are you doing this painting? How are you going to do it? Is there a certain purpose for painting it at this time? Are you creating a painting that is personal to you? Is it a commission piece or a competition piece? Is it a gift, a job or an experiment? Whatever your reason for creating a painting, a focus is needed. I call this the "Three *P*s." The *P*s stand for "Painting for Pleasure," "Painting for Profit" and "Painting for Prestige." As an artist, you must have an intense passion about your work or you wouldn't be a painter. But there will be times when you may feel less frustrated if you understand your focus.

Three Sisters
30" x 40" (76cm x 102cm)
Collection of Jeanette and Joe Nesler

Painting for Pleasure

You just want to paint "your thing" your way, as it gives you such pleasure! This is the reason you began painting in the first place. It's a natural high, a euphoria that touches all of your senses. It is a heavenly, almost mystical feeling that can only be experienced by people who create! It gives such a powerful sense of accomplishment when everything falls into place. I love the physical process of actually pushing the paint around, seeing with the wonderment of a child's excited eyes the creation of new color combinations. I didn't even know that some of these guys existed!

Imagine that personal power of putting yourself into that fantastic, secret world always filled with enthusiasm and energy! Don't you love watching a sheet of lonely, empty white paper suddenly materialize into a magical image? This is pure pleasure! Some of us were lucky enough as kids to have discovered this special place, giving us a lifetime of priceless experiences. If you are a novice to this world, come on in and join the party!

Exciting Accidents | While on a trip I happened upon a vintage car rally and shot several rolls of beautiful Rolls-Royce close-ups. When the film returned from processing, I was stunned to see that the film shoot of the grand autos had double exposed on film from an earlier studio shoot of rose and scarf still lifes.

IDEAS

When painting for pleasure, you generally have more ideas than time to do the paintings. Ideas can come from creating exciting accidents, stumbling upon intriguing objects or viewing life's everyday marvelous experiences. The majority of my work is very personal and even the titles relate to specific events in my life.

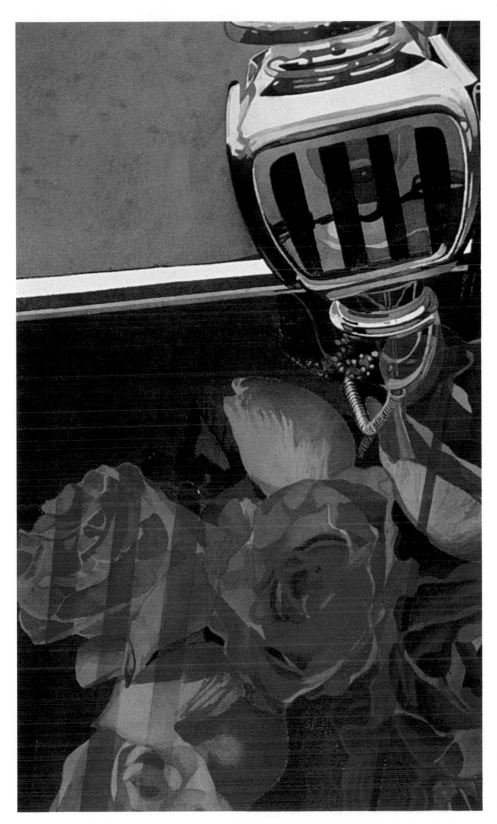

Double Exposure-Rose/Royce—Carriageway
Double Exposure Series
30" x 22" (76cm x 56cm)
Collection of Kimberly Brush

Painting for Profit

After a while there comes a time when you hope to sell some of the work stockpiled in your studio. It helps to understand why some of your watercolors sell and others don't. I have spent twenty-five years showing and selling at art festivals, exhibiting in galleries, running a wholesale reproduction business and entering a ton of competitions, and I have found that the majority of buyers pay attention to color first, then image or memory, size and price.

Color

I had a wise father-in-law who once said, "If you want to sell art, make art that sells." There are a group of people who buy art to "match their couch." As dedicated artists, we were taught in school that there are also people who collect original work from painters just because they like it. Unfortunately the numbers are in favor of the couch folks.

Once you accept this idea, you can do all kinds of terrific paintings your way with the colors or images that are popular at the time. (I know this makes us all crazy!) Go shopping, and look at the colors of clothing, towels, bedspreads, throw pillows, rugs, and so on. Gather swatches of paint and wallpaper samples. Look through magazines and ads to know what is visually timely.

Memory or Image

People love to collect things from vacations and exotic places. They relate to places they want to go. They wish to keep pieces of their experiences. Photographers figured this out a long time ago! For the artist, painting a memory could just be using subject matter that you already like: boats on the turquoise ocean, waving palm trees at the beach, blooming flowers in bright light. Look around you and paint the memories and images that appeal to you but might also sell to a large number of people.

Color Trends | These are examples of color samples for commission pieces.

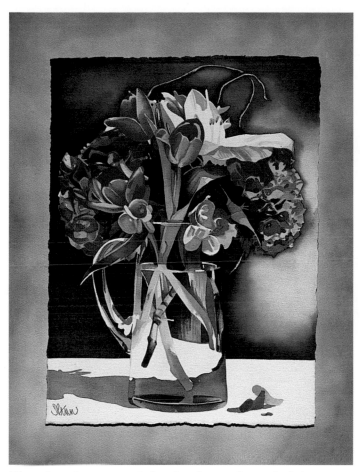

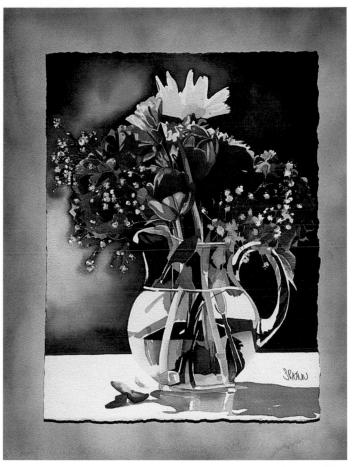

Summer Bride
28" x 22" (71cm x 56cm)
Collection of Sharon and Pete Wade

The spring colors were matched to the color swatches on the facing page. The lemonade pitchers were designed as a two-piece set with the handles and the shadows going away from the center.

Summer Groom
28" x 22" (71cm x 56cm)
Collection of Sharon and Pete Wade

Size

Paintings created to fit in specific areas of a home have a better chance of selling. I have found that horizontals outsell verticals due to places over sofas, bedsteads, dining room furniture, and the like. Small paintings can be placed in guest rooms, bathrooms and kitchens. Be aware of where you would like the painting to live. Stay focused!

Price

Price is a touchy issue due to all of us having realistic or unrealistic expectations of our hourly worth as painters. Look at the market for paintings similar to yours in size, image and skill level. At that point, a price range has already been set for the public. If your paintings sell too quickly, there is a good chance the prices are too low. If they sell too slowly but are terrific pieces of work, the prices may be out of line for the market.

Don't forget to triple the cost of the matting and framing. This is called a "triple keystone." Keystone one: It took money from somewhere to buy the supplies. Keystone two: It will take money to replace the supplies. Keystone three: You want money left in your pocket.

Size | This painting, with its long shape, would fit perfectly over a couch.

Sunset at Sanibel
35" x 60" (89cm x 152cm)
Collection of Helga and Ludwig Spiesel

Collectors

Collectors are the angels in our lives who love and respect our work. They have wanted to collect some of our paintings for aeons. For these people, we can paint for pleasure and do just about anything we want, as long as it is well executed. Our collectors will adore and adopt it. Bless you all!!

How do you find these special angels? By becoming better and stronger as a painter over the years, collectors will find you through galleries, shows, books, publications and exhibitions.

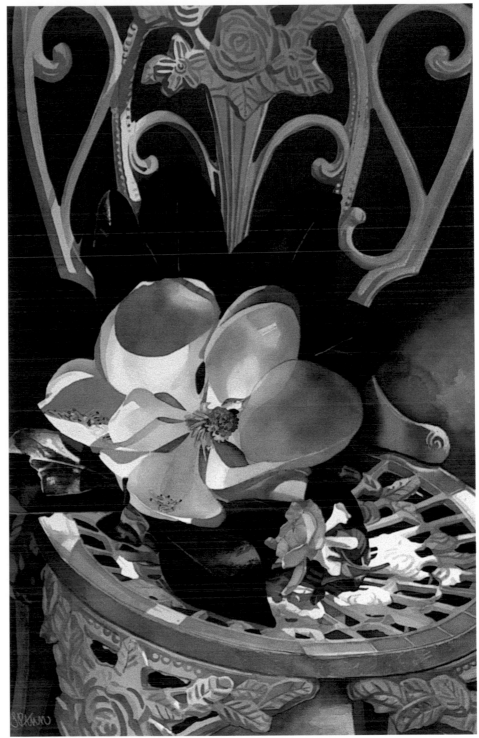

The lush greens and blues behind the grayed chair intrigued my collector. She has several paintings and wanted one with the beautiful magnolias of April which grow in her yard.

April's Passage
60" x 40" (152cm x 102cm)
Collection of Janette Dunnigan

Painting for Prestige

Prestige comes in several packages, including competitions, awards, publications, gallery shows, watercolor society affiliations and museum inclusions. We all want to receive some sort of attaboys after finishing our paintings.

Competitions

Painting competitions are found at various art leagues, city associations, church exhibitions and local art societies in your hometown. The chamber of commerce in the yellow pages of the phone book should be able to help you if you are new to an area. Once you feel comfortable with these competitions, take your best paintings and enter them in state competitions, such as that of the Florida Watercolor Society. Again, check local art leagues for information. Magazines will also list statewide competitions for you. *The Artist's Magazine* and *American Artist* list a cornucopia of competitions in the backs of their publications.

When you finally feel up to entering national competitions, the most prestigious are the American Watercolor Society Exhibition in New York City, the National Watercolor Society Exhibition in California, Watercolor U.S.A. in Missouri and Rocky Mountain National Watercolor Exhibition in Colorado.

How do you choose which painting to enter? The work has to be your absolute finest and best effort, not necessarily your favorite piece, and it has to quickly catch the eye of the judge. Each judge comes into the competition with his or her own points of view, likes and dislikes and mental list of requirements that constitute a prize-winning painting. Trying to second-guess a judge is like spitting in the wind!

Competition Tips

If two paintings are of equal quality, the larger one generally gets the nod.

Try to enter a subject matter that no one else would likely be entering. (If a judge sees one hundred beautiful white horses and then your gorgeous white horse sails by, he has seen enough.)

Research the judge's background. If he is a practicing painter, he will most likely understand and respect your media and the execution of the work. Enter your best unusual technical piece. If the judge has an academic background, she will most likely gravitate to the avant-garde, unusual use of materials or a more contemporary style. This is the time to enter your best abstract or uniquely designed painting. If the judge is affiliated with a museum, he is most likely to view flowers as the kiss of death. He may select types of paintings with serious colors or statements on society that could be in the galleries of New York or in the fine art magazines . Enter your best piece that fits this genre.

If a painting has a good track record of wins, enter that baby!

Focus on Competition | The unusual subject matter of a double-exposed photograph (with car parts, roses and lace) makes for a spectacular painting. The abstract composition and dramatic coloring catch the eyes of most judges.

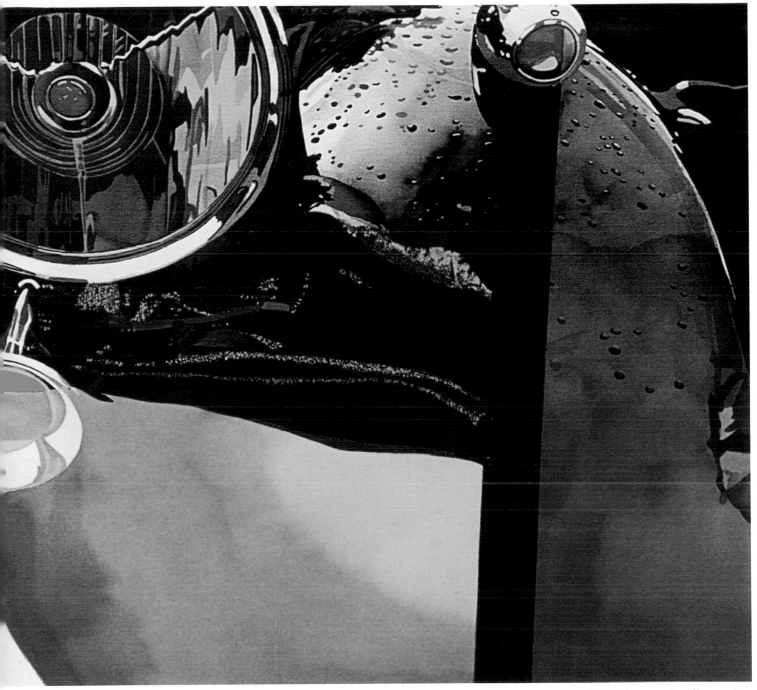

Double Exposure-Rose/Royce—Jazz
Double-Exposure Series
40" x 60" (102cm x 152cm)
Collection of the artist

Publications

To be published in a magazine article takes time and patience. Either wait for the magazine fairy to tap your shoulder and say, "I want you," or actually sit down and write an article. Publications are always on the lookout for new information with an appealing approach to painting. Take the time to look at the publications in which you hope to be published. See their formats before spending a lot of time writing. The same is true for a book. Today many art books have specific subject competitions and an artist's slides are always welcome.

Galleries

To be included in prestigious galleries, an artist must be technically proficient and appealing to the galleries' clientele. Look at the kind of work each gallery carries. Does your work complement and fit in? Talk to the director and find out what is needed to have your work included there.

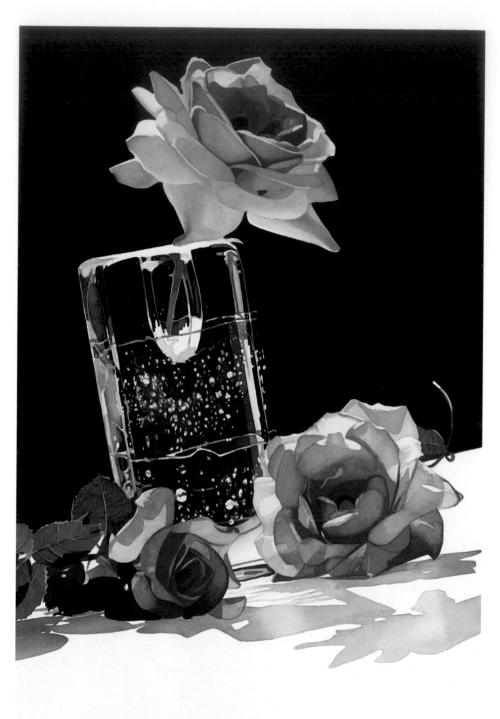

Get Published | I painted a demo of this piece for an article in *The Artist's Magazine*.

Rainy Day in Virginia
40′ x 30″ (102cm x 76cm)
Collection of Virginia White

Society Membership

If you wish to become affiliated with prestigious watercolor societies, begin locally. As your work gets stronger, enter the various state watercolor competitions. After a while, enter the national competitions.

To become a signature member in the National Watercolor Society (N.W.S.), an artist needs to be accepted in one exhibition. This is followed by sending three paintings to be judged by the N.W.S. membership committee.

For the American Watercolor Society (A.W.S.), an artist needs to have two paintings accepted within a ten-year span. This is also followed by sending in three paintings to the membership committee for judging. When the artist finally earns signature membership, he may place the letters *N.W.S.* or *A.W.S.* after his personal signature on his paintings.

Museums

For museum inclusion, an artist needs to be an innovator, creating work on the cutting edge and of museum quality. There are museums that include only artists from their state. Other museums include contemporary work that is global in scope. Like anything else, there are many different kinds of museums. If this is your focus down the line, learn what it takes to make this dream bloom.

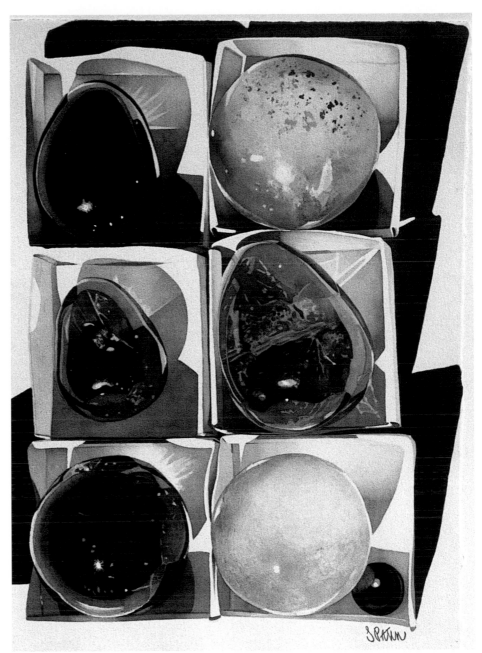

Earn Membership | This painting helped me earn membership in the N.W.S. and A.W.S.

Jim's Gems
Crystals in Containers Series
40" x 30" (102cm x 76cm)
Collection of Tamara and Joseph Lamoureux

Gallery

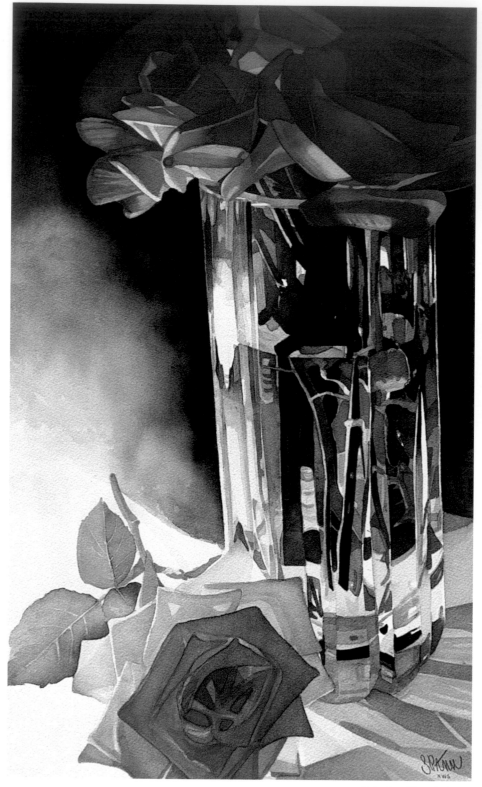

Enjoying Ginny's House
40" x 30" (102cm x 76cm)
Collection of Dr. Ransford Pyle

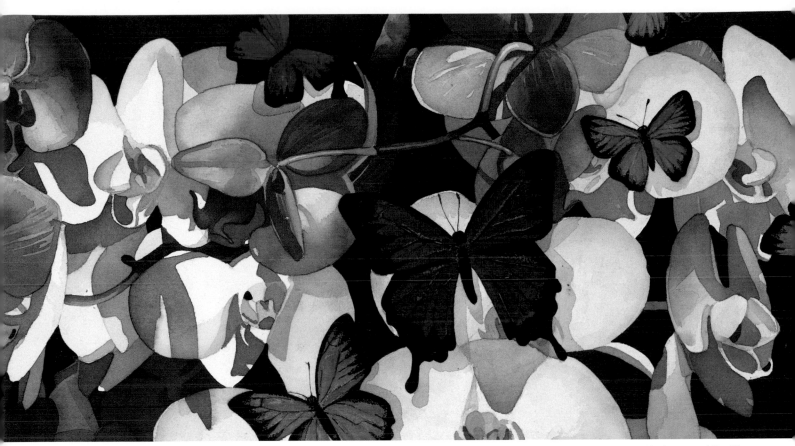

Mariposa and Papillon
20" x 50" (51cm x 127cm)
Private collection

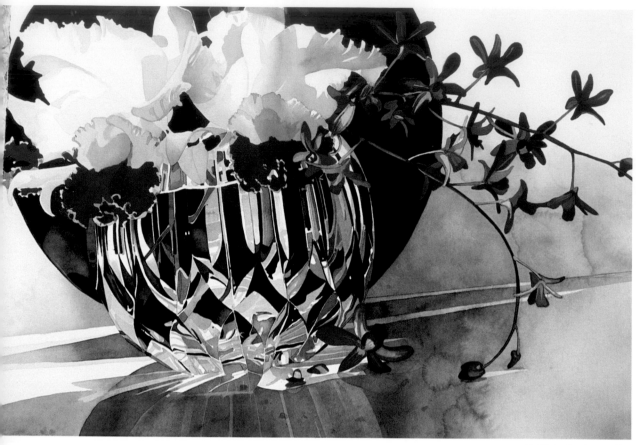

Twilight in the Rockies
30" x 40" (76cm x 102cm)
Collection of Lisa Henderson

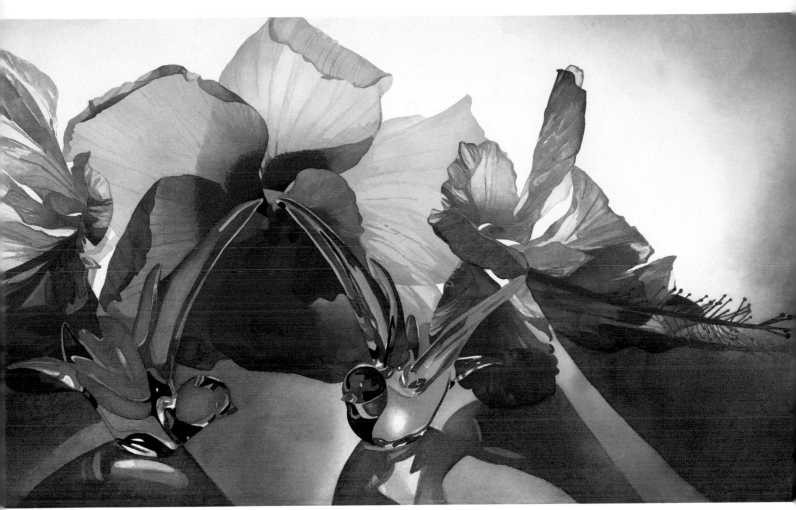

Guards at the Gate
35" x 60" (89cm x 152cm)
Collection of Joan and William Holt

Index

Master Watercolor Painting With North Light Books!

Are your watercolors weak, listless —"wishy-washy"? Maybe you lack confidence, don't put enough paint down, are afraid to use darks...

Whatever ails your paintings, help is here! You'll learn strategies to get out of that wishy-washy rut and start paining vital, imaginative watercolors. Five complete step-by-step demos show you how, resulting in stronger, bolder, more artistic results.

0-89134-876-X, hardcover, 128 pages

Infuse your watercolors with breath-taking qualities by portraying the exquisite beauty of flowers from a close-focus point of view.

This book shows you how by providing easy-to-learn techniques for mingling colors and manipulating light, insights into the "character" of petals, advice on designing your composition, choosing materials, preparing for setup and more. You'll portray the stunning splendor of flowers as never before.

0-89134-947-2, hardcover, 128 pages

Professional-looking paintings start with good composition. And there are two paths to good composition: the hard way (cross your fingers and hope for the best) and the easy way (use the simple techniques in this book).

Inside, you'll find everything you need to build a strong and engaging composition every time. This book makes you the master of your compositional fate!

0-89134-891-3, hardcover, 128 pages